FITZWILLIAM MUSEUM
HANDBOOKS

# BRITISH PORTRAIT MINIATURES

The collection of portrait miniatures in the Fitzwilliam
Museum gives a compact and comprehensive survey of
the development of this art form. It illustrates its pro-
gress through the work of almost every major master
in the genre, with works of the highest excellence.
This book provides an introduction to the history of
British portrait miniatures; ninety-six items from the
collection are described, and each item is illustrated
in full colour, to bring out the subtlety and
intimacy of this delicate art form.

FITZWILLIAM MUSEUM HANDBOOKS

# BRITISH PORTRAIT MINIATURES

GRAHAM REYNOLDS

PHOTOGRAPHY BY ANDREW NORMAN

CAMBRIDGE
UNIVERSITY PRESS

PUBLISHED BY THE PRESS SYNDICATE OF THE UNIVERSITY OF CAMBRIDGE
The Pitt Building, Trumpington Street, Cambridge CB2 1RP, United Kingdom

CAMBRIDGE UNIVERSITY PRESS
The Edinburgh Building, Cambridge CB2 2RU, United Kingdom
40 West 20th Street, New York, NY 10011–4211, USA
10 Stamford Road, Oakleigh, Melbourne 3166, Australia

First published 1998

Printed in the United Kingdom at the University Press, Cambridge

Typeset in Quadraat 9.5/13.75pt, in QuarkXPress™ [SE]

*A catalogue record for this book is available from the British Library*

*Library of Congress cataloguing in publication data*

Reynolds, Graham.
British portrait miniatures / Graham Reynolds.
p.   cm. – (Fitzwilliam Museum handbooks)
ISBN 0 521 59202 x (hardback). – ISBN 0 521 59781 1 (paperback)
1. Portrait miniatures, British–Catalogs.
2. Portrait miniatures–England–Cambridge–Catalogs.
3. Fitzwilliam Museum–
Catalogs.   I. Title.   II. Series.
ND1337.G72R492   1997
757'.7'094107442659–dc21   97–5756 CIP

ISBN 0 521 59202 x hardback
ISBN 0 521 59781 1 paperback

# CONTENTS

Preface ix

Introduction 1

v

# PREFACE

The strength of the Fitzwilliam Museum's collection of British portrait miniatures comes from a fortunate combination of benefactions and enlightened curatorship. The core of its representation of the earlier artists is provided by the L.D. Cunliffe bequest of 1937. Over a quarter of the miniatures in this selection come from that one source, which was especially strong in the earlier artists. It is matched by the acquisitions made by two successive Directors, Louis Clarke and Carl Winter. The finely judged purchases made by Dr Clarke were enhanced by his bequest, which included many fine works of the late eighteenth century. Carl Winter had been in charge of the national collection of portrait miniatures at the Victoria and Albert Museum, where in particular he undertook a pioneering study of Nicholas Hilliard and Isaac Oliver. This enabled him to expand and balance the representation of those masters and their successors, both through his advice to Louis Clarke and by the purchases made for the collection during his period as Director. By then it was, amongst public collections, second only to that in the Victoria and Albert Museum.

The scope and excellence of the collection was apparent to the Museum's visitors. It became more widely known when a complete catalogue of its contents was published in 1985. Fully descriptive and illustrated, this was the work of the Honorary Keeper of Miniatures, Robert Bayne-Powell. He was himself a dedicated collector, with a special interest in the miniaturists of the nineteenth century. Two of the later works in this selection had belonged to him: he bequeathed the portrait of a lady by Sir William Ross, and the portrait of a man by George Richmond was bought by the Museum at the sale of his collection in 1994.

The present selection reproduces about a third of the English miniatures in the collection. They are arranged in the chronological order of their painters and have been chosen to represent the most interesting and accomplished pieces, and to provide a framework for a condensed history of miniature painting in this country.

# INTRODUCTION

The British have a long tradition of admiration for portraiture. In particular they have been enthusiasts for that special type of intimate and portable image, the portrait miniature. For over 300 years, from the early sixteenth century until the mid-Victorian era, there was a continuously growing demand for miniatures, and an ever expanding number of artists qualified to satisfy that demand.

The collection of miniatures in the Fitzwilliam Museum gives a compact and comprehensive survey of the development of this national art. It illustrates the course of its progress through the work of almost every major master in the genre, usually with works of the highest excellence. Its range is confirmed by the fact that any condensed survey of its history, such as the following, can be illustrated from the collection by typical and often outstanding examples by the most significant artists.

The portrait miniature was imported, like so many new ideas, by Henry VIII. Its inception can be traced to a text written in 1519–20 for Francis I, King of France. This manuscript includes small portraits of the seven heroes of the Battle of Marignan, fought in 1515. These are portrait miniatures in every sense except that they have remained on the pages of a book rather than being cut out and individually mounted in a locket or portrait box. The artist was Jean Clouet, painter to the King of France. The portraits, which are small roundels, pay tribute to the classical precedents of the medal and the cameo. They are painted in a technique based upon the illumination of manuscripts, that is, watercolour on vellum.

The small portrait had been emancipated from the manuscript by the time the earliest miniature in the Museum's collection, no. 1, was produced. When Henry VIII set about transforming the English court into a centre of humanism he sought to attract eminent artists to it. Francis I had recruited Leonardo da Vinci; Henry VIII must employ Holbein. Before that, he had enlisted a counterpart to Jean Clouet in the person of Luke Horenbout. Horenbout came of a distinguished line of Flemish illuminators. It is an unresolved question whether the first really independent portrait miniature was produced in France by Clouet or in England by Horenbout. Certainly small portraits in lockets were exchanged between the Courts, in 1525 and 1526. It is most probable that a version by Luke Horenbout of no. 1 was the portrait of Henry VIII included in this exchange.

1

Hans Holbein learned the technique of this new type of portraiture from Horenbout, and by his consummate skill ensured its lasting place in national taste. Holbein's greater ability did not deprive Horenbout of his occupation. He remained in Henry VIII's pay, at a salary slightly higher than that of Holbein, and he seems to have retained the monopoly for miniatures of the King. The Museum has no work by Holbein, but the sharpness of vision and precision of style which he introduced is echoed in the anonymous miniature of Sir Nicholas Carew (no. 2).

The origins of Horenbout and Holbein in Northern Europe entailed that English portraiture in the first half of the sixteenth century was pervaded by the intense realism of the Flemish school. They were followed by an English born painter who brought a conspicuously different approach to the portrayal of his countrymen. Nicholas Hilliard claimed fidelity to the Holbein tradition: 'Holbein's manner of limning I have ever imitated, and hold it for the best' he wrote. He was exposed to other European influences when, as a child, he was an exile from religious persecution in Switzerland, and he studied engravings by Dürer, Suavius and Goltzius. But from these beginnings he evolved a way of seeing people which is unmistakably English. He adapted the linear elongations of the Mannerists to his own method of composition. Early in his career he found a sympathetic sitter in Queen Elizabeth I. She revealed to him her dislike of strong shadows in portraiture. The ideal, she told him, was to be portrayed sitting out of doors where no cast shadows could darken the face. Hilliard paid due attention to this regal advice, even though most of his miniatures were painted in a studio. His abilities soon gained wide recognition, and his productive career provides the first example of a painter who specialised in miniatures and whose clientele stretched beyond the confines of the Court. He had been trained as a goldsmith, and also practised that art throughout his life. His portrait of Queen Anne of Denmark (no. 9) is enclosed in an elaborate locket which demonstrates the close connection between portrait miniatures and personal items of precious jewellery.

The Museum's collection is notably rich in its representation of Hilliard's work. It shows his confident beginnings in two miniatures of the 1570s (nos. 3a and b), and has six works painted in the 1590s when he was at the peak of his achievement (nos. 4–8). These include one of the many portraits he painted of Queen Elizabeth I (no. 4a) without repeating the intricate details of her bejewelled costume, and the earliest portrait of Southampton, when he was Shakespeare's patron (no. 4b).

Hilliard's technique was adapted to the convention that miniatures are, in

his own words 'small pictures which are to be viewed in hand'. But he did sometimes paint a larger and more public type of miniature portrait, the 'cabinet' miniature. The unfinished example here (no. 8) gives a valuable insight into his method of laying in the outline with a neutral tone and shows his progress towards the completion of the features and background.

Hilliard taught many pupils; amongst them Isaac Oliver achieved most fame and success. He was some twenty years younger than his master and, as the son of a Huguenot refugee, never lost touch with his European antecedents. His cosmopolitan style appealed to Queen Anne of Denmark and Henry Frederick, Prince of Wales. Isaac Oliver reflected the trend towards the Flemish style of vision seen in the contemporary painters of large scale portraits, notably Gheerhearts and Van Somer. He then travelled in Italy and learned from the Venetian artists. The large roundel of Lucy Harington (no. 12) is one of his most masterly works, and mediates those Continental influences through his own sharp powers of observation and decorative finesse.

Isaac Oliver passed his skills on to his son Peter Oliver whose early works were *ad vivum* portraits made in close imitation of his father's later, *sfumato* manner. These are represented in the Museum's collection by three fine examples (nos. 14, 15a and 15b). But Peter Oliver was diverted from original composition by an increasing demand in the court of Charles I for limned copies from other artists. The continuity of portrait miniature painting was maintained by the nearly contemporary John Hoskins. He had started as an oil painter working in the manner of de Critz, but seems to have known Hilliard and came to specialise in limning. The many changes in Hoskins's style over the next forty years reflect the transitions in taste from Van Somer, Mytens and Cornelius Jonson to the supremacy of Van Dyck. The Museum's collection represents only the later strand in Hoskins's career, when he had fully assimilated the impact of Van Dyck and based his own style upon it (nos. 20, 21). His miniatures were often valued more highly by his contemporaries than large portraits. Sir Kenelm Digby wrote that 'The best faces are seldom satisfied with Van Dyck; whereas not the very worst ever complained of Hoskins.' This claim does not seem extravagant when measured against so sober and refined a portrait group as that of three children of Charles I (no. 19).

Samuel Cooper, the nephew and ward of John Hoskins, was trained in his uncle's studio and surpassed him in achievement and reputation. His bold brushwork and sharply angled lighting emphasised the characteristics most observed in the Baroque age: in men, rugged complexion, wrinkles, pouches under the eyes, warts, roughness of skin; in women, languorous eyes and

3

tempting *espièglerie*. Cooper was renowned in the courts of Christina of Sweden, Louis XIV of France and Cosimo III of Tuscany. He represents the high point of achievement in seventeenth-century limning. Such contrasting images as those of Mrs Elizabeth Leigh (no. 22a) and the Rev. Thomas Stairsmore (no. 23b) show his sympathy with feminine grace and his understanding of severe masculinity.

Cooper's chief follower was the versatile Thomas Flatman, whilst the more *pointillé* style of Hoskins was adopted by Nicholas Dixon and Peter Crosse. Crosse was the last English born miniaturist to maintain the seventeenth-century tradition of limning into the first decades of the eighteenth century. The long succession of native artists then came to a temporary standstill, and a fresh impetus came from abroad. It was given novelty by two significant changes in technique. For the first century of its practice the miniature had typically been painted in watercolour on vellum. Gradually the parallel method of the enamel miniature, a ceramic fired on metal, was developed. Jean Petitot was the chief exponent of this change. He started his long and immensely productive career at the court of Charles I, and received some training from Van Dyck, but the Civil War drove him back to France, where he dominated small scale portraiture for over forty years.

At first enamels were far more popular on the Continent. But when the succession of English-born miniaturists faltered at the end of the seventeenth century, enamellists who had learned their craft in Europe brought their skills to England. Charles Boit was instructed in Stockholm and Paris before joining his fellow Swede Michael Dahl in England. As his portrait of the 2nd Duke of Rutland shows (no. 33) he was competent and ambitious in scale. He trained C.F. Zincke in the technique, and in his hands enamel became the dominant medium for miniature painting in England in the first half of the eighteenth century.

But enamel was not the only innovation. Just before 1700 Rosalba Carriera had turned to ivory as a base on which her miniature portraits could be painted. In England Bernard Lens was amongst the first to adopt this material, and the Museum possesses a particularly charming example in this new technique by an artist whose work is often gauche (no. 34).

For the first half of the eighteenth century miniatures on vellum, on enamel and on ivory existed side by side. Some artists of the next generation, amongst them Gervase Spencer and Nathaniel Hone, practised with equal assurance in all methods.

The dominant large-scale portrait painters in the early eighteenth century were Kneller and Dahl. The air of solid North European solemnity which they

impressed upon their sitters was echoed in the miniatures of Lens and Zincke. It was a manner against which Hogarth, impelled by a fierce spirit of nationalism, fought might and main. His search for the Englishness of English features was joined by the modest school of miniature painters who took over from them. One reason for the small scale on which they worked is found in the contemporary fashion for wearing miniature portraits as bracelets on wristbands or as brooches. In this phase of the art Gervase Spencer and Nathaniel Hone convey an impression of innocent charm.

This quiet interlude was followed by a second flowering of the national school. Its leaders exploited to the full the potential of ivory as a polished white surface which provided luminosity of colour by the clarity with which it transmitted light through transparent pigment.

The first great master of this revival was Jeremiah Meyer. He had been trained by Zincke, but the miniatures with which he transformed the late eighteenth century were on ivory. His individual style of draughtsmanship is most apparent in the miniatures he painted on relatively large sheets of ivory. The difference of scale may seem negligible, but the ivory used for no. 39 gave the artist over seven times the surface area of nos. 36a and b on which to work. Since Meyer's painting depended on boldly expressed lines and pronounced cross hatching it was much more effective in the larger format. Meyer's repute was unrivalled in his own time. He was George III's favourite miniature painter and became the only miniaturist to be elected as such as a founder member of the Royal Academy.

The impetus which Meyer gave to the revivification of the miniature was sustained by a whole group of masters born in the early 1740s. The most outstanding was Richard Cosway, who won the patronage of the Prince of Wales through a successful portrait of Mrs Fitzherbert. He is well represented here by such characteristic instances of his allusive painting as the portrait of Lady Eardley (no. 44), in which the image is lightly sketched on the ivory with soft grey curving strokes. Ozias Humphry is represented by only one miniature, but it displays his much more intense colouring. John Smart provides another contrast of style in the meticulous and detailed finish which give his miniatures on ivory the smoothness of enamels. Richard Crosse followed the linear style of Meyer, on which he imposed a predominantly greenish-grey tonality.

In the next decades these miniaturists were joined by the immensely prolific George Engleheart and by Cosway's protégé, Andrew Plimer. Miniature painting was now in great demand. The leading artists were well employed: Richard Crosse painted 100 miniatures a year and George

Engleheart once as many as 228. Their efforts were seconded by scores of talented minor practitioners, attracted by an enlarging patronage and the publicity given by public exhibition.

The Museum's collections do not show these secondary artists in any great numbers. Their quality and individuality can be appreciated in the examples by Philip Jean, John Barry and Horace Hone.

The late eighteenth century we see in its portraits is an age of colour and elegance. The nineteenth century introduced a more austere note into fashion and this change of mood is echoed in the miniatures of the time. George Engleheart lived long enough into the new century to reflect the change. Nor is the development noticeable only in the colour of men's costume (other than military uniforms). There were changes in the technique and shape of the miniature. The artists who came to prominence in the early years of the century were dissatisfied with the methods of their predecessors, and set about promoting a radical alteration in the foundations on which their art had been based. The newcomers, led by Andrew Robertson, condemned their predecessors for passing off sketches as finished pictures. They set about transforming their works on ivory into small imitations of oils. Concurrently they favoured the rectangular shape for their portraits, to a degree which showed that they no longer thought that the miniature was a token to be held in the hand and cherished as a private image. Much of the new miniaturists' work was to be displayed on the desk or hung with paintings on the wall. The Museum has no work by Andrew Robertson, the leader of this change in taste. But his impact can be assessed through the miniature by his one-time assistant and most important disciple, Sir William Ross.

The two most notable nineteenth-century portraits here were painted by artists who did not regard themselves primarily as miniature painters. Severn's portrait of Keats is a personal record of friendship. Linnell plumed himself on the new appearance he brought to miniature painting but never concealed the reluctance with which he undertook portraiture. His miniature of Blake is one of a group of records he made to mark his intimacy with the man he so much admired.

Ross was the last great master of English miniature painting. By the end of his life it had become apparent that the newly invented art of photography met the main demand for small portraits. The *carte-de-visite* had replaced the miniature on ivory. The decline in patronage for the older art was dramatic. Miniaturists did continue to paint in the traditional way for a constricted group of patrons. But a livelier contribution to this diminishing field was

made by the *fin-de-siècle* designer Charles Ricketts, in his one venture in the art. When painting the profile of his friend Edith Cooper (no. 64) he reverted to first models for the miniature: the cameo and the medal. Also, by designing a jewelled locket for this portrait, he returned to the practice of the early masters such as Hilliard. In this way the most recent portrait in the collection links up with the Renaissance origins of miniature painting.

### GENERAL NOTES

The miniatures are fully catalogued in the *Catalogue of Portrait Miniatures in the Fitzwilliam Museum, Cambridge* by Robert Bayne-Powell, published by the Cambridge University Press, 1985. In this handbook the relevant entries are identified by the page number in that catalogue, thus: BP., p.oo following the Museum's accession number for the miniature. The *Catalogue* gives details of provenance and references to previous literature. It also provides a full discussion of the attributions and of the identifications of the sitters.

No. 58 was not available for the *Catalogue*, and nos. 47a, 62 and 63 are not in BP and have been added to the collection since its publication. The attribution of no. 9 has been restored to Nicholas Hilliard and that of no. 10a to Isaac Oliver. The traditional identifications of the sitters in no. 12 and no. 23b have been retained, and that of no. 56a rectified.

In this handbook the word 'limning', referring to works produced in the sixteenth and seventeenth centuries, is synonymous with 'miniature painting'.

The photographs were taken by Andrew Norman, one of the Museum Photographers, and their production was supervised by Andrew Morris, Chief Photographer.

### FURTHER READING

*On the history of English miniature painting:*

John Murdoch et al. *The English Miniature.* Yale University Press 1981.

Graham Reynolds. *English Portrait Miniatures.* Revised edition, Cambridge University Press, 1988.

Article 'Miniatures' in the *Macmillan Dictionary of Art 1996.*

Articles on individual artists in the *Dictionary of Art.*

*These sources contain further bibliographical references, as do the entries in the Bayne-Powell catalogue.*

# LUCAS HORENBOUT (d. 1544)

—

HENRY VIII (1491–1547)

*Vellum on card. Rectangular.* 2$^1$/$_8$ × 1$^7$/$_8$ in. 53 × 48 cm.

PD.19–1949. BP, pp. 128–30.

This is the earliest work in the collection, and is of unique significance as the first independent portrait miniature produced in England. The painter, Lucas Horenbout, was a member of a Flemish family who left Flanders for England in the early 1520s. His father Gerard Horenbout was Court Painter to Margaret of Austria, Regent of the Netherlands and in that role produced a number of finely illuminated manuscripts. This portrait is painted with the materials of the illuminator, watercolours on vellum, and with the same fine gradations of tone and attention to detail. Lucas Horenbout instructed Holbein in miniature painting, and thereby established the principles on which the subsequent advance of miniature painting was based.

Horenbout soon became a favoured artist with Henry VIII and is known to have produced at least six versions of this portrait of the King. It was heralded by an illuminated initial letter on a legal document of 1524; the remaining five, dating from about 1526, are all miniatures in the accepted sense. This is the prime version, since it is the only one embellished with a decorative surround. The border depicts angels supporting the initials H and K, entwined with cords to symbolise the love of Henry VIII for Katherine of Aragon. Ironically at the very time this token of affection was being painted the King was starting the proceedings which eventually led to his divorce from his first Queen.

By portraying the King at the age of thirty-five this miniature gives a less formidable impression of his appearance than that provided by the more familiar portraits made by Holbein ten years later. It accords with the widely expressed view that Henry was a handsome young man, described by one contemporary as having 'a round face so very beautiful that it would become a pretty woman'.

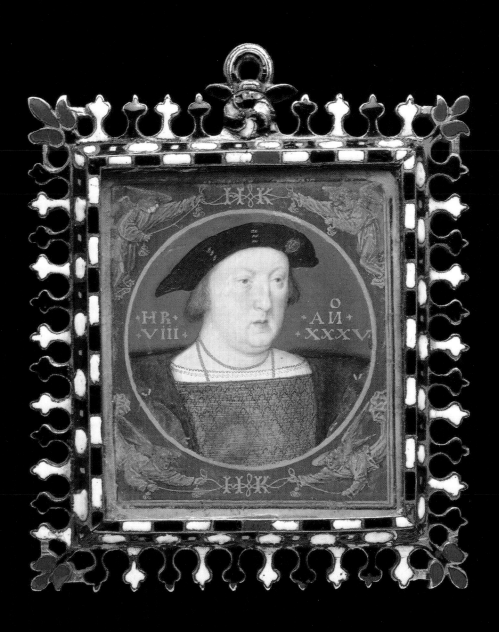

# UNKNOWN ARTIST. ENGLISH SCHOOL, SIXTEENTH CENTURY

—

SIR NICHOLAS CAREW (d.1539)

*Vellum. Circular. 1⅝ in. 40 mm. diameter. No. 3896. BP, p.122.*

The Museum's collection does not contain any miniature by Holbein, the greatest practitioner of the art, who had learned the technique from Luke Horenbout (see no. 1). But this sixteenth-century miniature of fine quality reflects the sharpness of vision and perception of character which Holbein introduced into limning.

There is a chalk drawing of Sir Nicholas Carew by Holbein in the Kunstmuseum, Basel. However this miniature is not derived from that drawing or from the paintings based upon it. It is a miniature copy of another oil painting of Carew which is known as the 'Newbattle Abbey' portrait because it belonged to the Marquess of Lothian. Even at second hand it embodies many of the characteristics which are found in Holbein's own miniatures, for instance the clarity of light and pronounced three-dimensional modelling of the face. But there are features individual to the artist, to be seen for instance in the dotted eyebrows and stippled beard. The gold background in place of the customary blue is an unusual element in miniatures of the period. Its authorship has to be sought amidst the imperfectly understood range of artists working in Holbein's wake in the sixteenth century.

Sir Nicholas Carew was a close early friend of Henry VIII. He sometimes presumed upon this intimacy by indulging in over familiar behaviour which led to his temporary banishment from the English Court. As an envoy to France he became a favourite with Francis I, King of France, at whose request he was made a Knight of the Garter in 1536. Three years later he was convicted of having shared the treasonable views of the Marquis of Exeter on the need of a change in the realm. He was executed on Tower Hill on 3 March 1539.

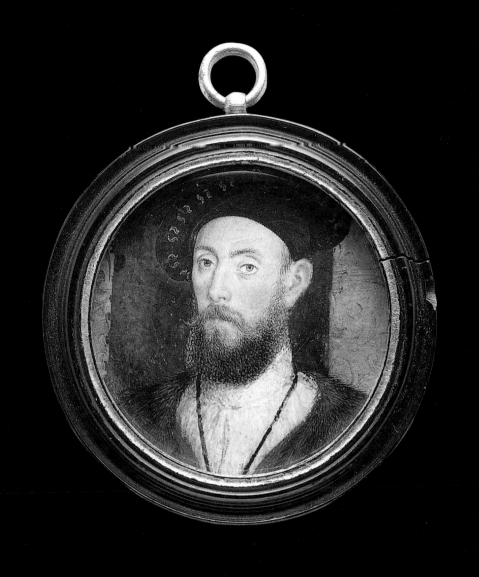

# 3

## NICHOLAS HILLIARD (1547–1619)

(A) AN UNKNOWN MAN, 1572 · TOP

*Vellum laid on playing card (three spades visible). Circular. 1³/₄ in. 46 mm. diameter.*
*Inscribed 'Anō Dni 1572 Ætatis Sue . . .'. No. 3899. BP, p.109.*

(B) AN UNKNOWN MAN AGED 37 IN 1574 · BOTTOM

*Vellum laid on playing card (two spades visible). Circular. 1⁵/₈ in. 40 mm. diameter.*
*Inscribed 'Anō Dni 1574 Ætatis Sue 37'. PD.20–1949. BP, p. 110.*

Nicholas Hilliard completed his apprenticeship and was made free of the Goldsmiths Company in 1569. He then embarked on a productive career as a miniature painter which established him as the master limner of his time. These two miniatures are fine examples from the first decade of his career. His distinctive manner is already apparent in such details as the broad massing of the hair and the well-defined shadow under the top eyelid. Although neither sitter has been identified their bearing expresses the confidence and exuberance of the early Elizabethan court. This is reflected in the neatly trimmed moustache and beard, the tightly fitting high-necked doublet and, in the lower miniature, the feather adorning the bonnet.

The age of the sitter in the top miniature has been erased in an attempt to support an untenable identification with Edward Courtenay, Earl of Devon, who had in any case died in 1566.

For a long time Hilliard was believed to have been born in 1537, instead of 1547. This lent plausibility to the mistaken identification of the lower miniature as a self-portrait. More recent attempts to identify the sitter as Robert Dudley, Earl of Leicester have also to be abandoned. The inscription has not been altered and he was aged forty-two in 1574. Even without positive identifications, Hilliard's insight into the characters of these two men gives an immediate impression of the adventurousness and presumption professed by the Queen's courtiers. Hilliard himself shared these qualities: in the 1570s he joined a group prospecting for gold in Scotland.

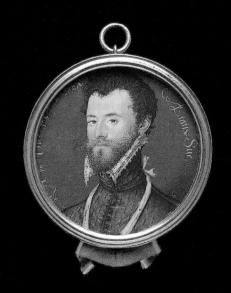

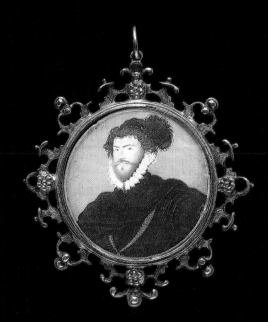

# NICHOLAS HILLIARD

—

(A) QUEEN ELIZABETH I (1533–1603) · TOP

*Vellum laid on card. Oval. 2¹/₄ × 1³/₄ in. 58 × 45 mm. No. 3761. BP, p. 112.*

(B) HENRY WRIOTHESLEY,

3RD EARL OF SOUTHAMPTON (1573–1624) · BOTTOM

*Vellum laid on playing card (three hearts visible). Oval. 1⁵/₈ × 1¹/₄ in. 41 × 32 mm.*
*Inscribed by the artist in gold 'Ano Dni 1594 Etatis suae 20'.*

*No. 3856. BP, p. 114.*

(A) Nicholas Hilliard recounts a conversation he had with Queen Elizabeth I in which she expressed her dislike of overmuch shadow in painting. The conviction with which he met her views on portraiture led to his employment as her miniature painter throughout her reign. Over twenty Hilliard miniatures of her are now known. In the later miniatures, of which this is an unusually elaborate example, he invested her with the attributes of eternal youth. No repetition is identical, since he varied details in the dress and accessories. As a goldsmith Hilliard took a keen interest in jewels. In his autobiographical 'Arte of Limning' he gives a glowing account of their significance and describes his technical devices for representing them in his miniatures. The jewels in this portrait are based on card symbols, diamonds, spades and clubs (the hearts suit may be taken to be represented by the Queen herself). The flowers behind the Queen's are a characteristic Hilliard embellishment.

(B) Henry Wriothesley, 3rd Earl of Southampton, was a lavish patron of the arts from his youth. This is the earliest known portrait of Southampton, and was commissioned in the year in which Shakespeare dedicated 'The Rape of Lucrece' to him in terms of the warmest friendship: 'What I have done is yours; what I have to do is yours.' Southampton is depicted with the excessively long hair for which he was notorious at the Elizabethan court. He is seen some twenty-five years later in the miniature by Peter Oliver, no. 15a.

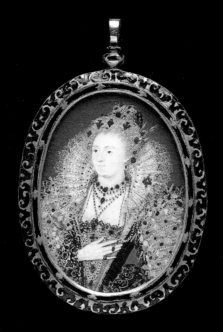

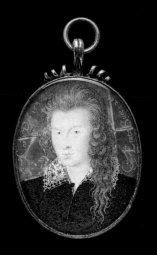

# NICHOLAS HILLIARD

—

## AN UNKNOWN LADY

*Vellum laid on a playing-card. Oval. 2⁷/₈ × 2¹/₈ in. 73 × 53 mm.*
No. 3898. BP, p. 113.

In his autobiographical 'The Arte of Limning' Hilliard expresses his delight in
the features of his countrywomen, which he extols above all other nations:
'rare beauties are . . . more commonly found in this isle of England than else-
where'. He goes on to caution the painter against losing his heart to his beauti-
ful sitters: 'He can . . . hardly . . . express them well, without an affectionate
good judgment, and without blasting his young and simple heart.' He contin-
ues with a rhapsody on the changes seen in a smiling face: the lift of the
mouth, the nostrils and the cheeks, whilst 'the forehead casteth itself into a
plain as it were for peace and love to walk upon'.

This miniature embodies his enthusiasm and his sympathetic response to
his sitter's personality. It also provides a conspicuous example of his skill in
rendering the minute details of the elaborate Elizabethan costume. The mas-
terly way in which he follows the linear complexity of the Italian lace over the
black bodice is matched by the refinement of the jewels and the symbolic
cherry sprig pinned to her dress. Hilliard delighted in the fine rendering of
such intricacies. The form of the ruff, also made of elaborate lace and rising in
enlarging folds to the back indicates that the miniature was painted c. 1595.
Various attempts have been made to identify this beautiful young court lady,
but without success.

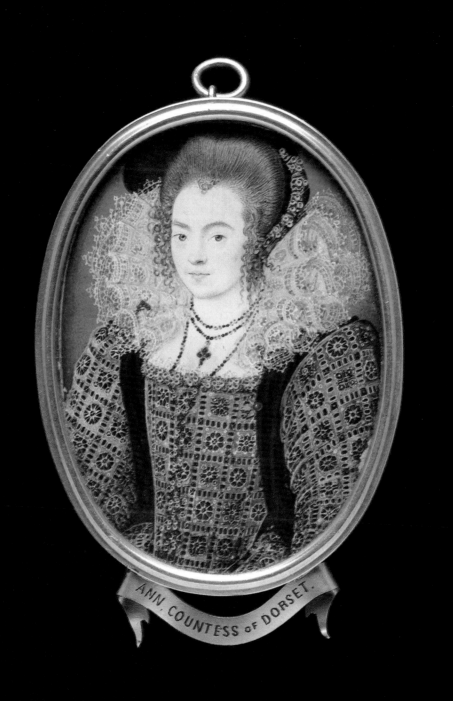

ANN. COUNTESS OF DORSET.

# 6

## NICHOLAS HILLIARD

—

SIR HENRY SLINGSBY (1560–1634)
*Vellum laid on card. Oval. 3¹/₄ × 2¹/₂ in. 84 × 63 mm.*
*Inscribed by the artist in gold: '1595 Æs 35'. The sitter's black hat is*
*embellished with a gold edged green enamel badge with the motto 'Semper Idem'.*
*The card at the back is inscribed, probably in late seventeenth-century hand,*
*with the identification of the sitter: 'Sr Hen Slingesby | father to*
*Sr Henry | Slingesby beheaded | by Oliver Cromwell.'*
*No. 3850. BP, p. 115.*

This miniature is larger than is normal for Hilliard's oval miniatures. The curtain background is painted with a wet brush on wet paint in a similar way to that seen in no. 8.

Sir Henry Slingsby was the head of a prominent Yorkshire family. He was knighted by James I in 1602, seven years after this portrait was painted. He became High Sheriff of Yorkshire in 1611–12 and was Vice-President of the Council of the North in 1629. The Fitzwilliam Museum also has an oil portrait of him, no. 2051.

The family's motto was 'Veritas Liberavit', and the motto in the badge is a personal affirmation of the sitter's inflexible will. These qualities were inherited by his son, who supported the King's cause during the Civil War and was beheaded in 1658 for plotting a Royalist rising in Yorkshire.

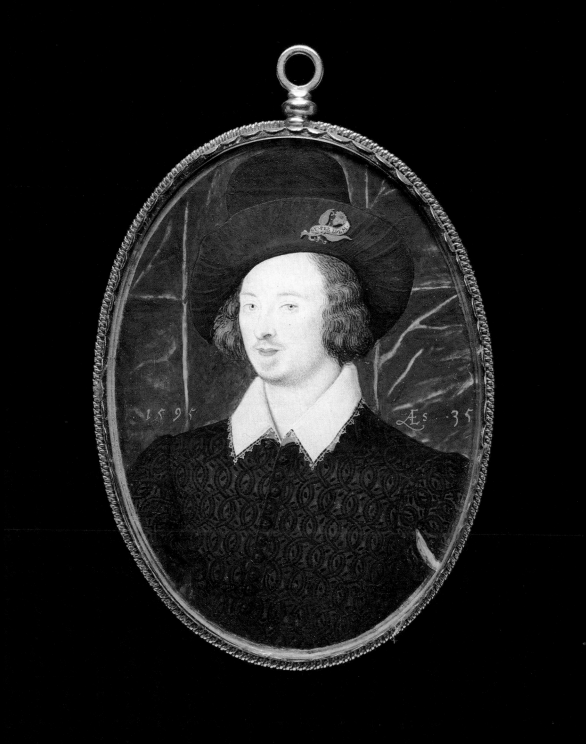

# NICHOLAS HILLIARD

—

HENRY PERCY, 9TH EARL OF NORTHUMBERLAND (1564–1632)
*Vellum laid on playing card (three hearts visible). Oval. 2 × 2¹/₂ in.*
*52 × 64 mm. PD.3–1953 BP, pp. 117–18.*

Hilliard painted another version of this portrait in the form of a cabinet miniature (see no. 8), which is now in the Rijksmuseum. In the larger, rectangular, miniature the Earl is seen full-length reclining contemplatively in a walled garden. A sphere balanced by a feather proclaims the power of the written word. The idea was current in this age devoted to symbolism. In his comedy 'The New Inn, or Light Heart' Ben Jonson uses it for the inn sign, which the landlord explains:

> An heart weigh'd with a Feather, and outweighed too;
> A Brain-child of my own and I am proud on't.

In this version Hilliard has retained the pleasure in landscape, seen in the larger portrait, giving expression to his delight in the open air life. The flowers, poppies, buttercups and pinks, recall those in his famous 'Young Man against a Tree amongst Roses'. The glove carelessly flung down and the open book show that the Wizard Earl has interrupted his reading for meditation. Henry Percy, 9th Earl of Northumberland, was an ardent scholar and collector. His interest in astrology and alchemy led to his being called 'The Wizard Earl'.He was a keen gardener, and amongst the few English books he had during his long imprisonment in the Tower for implication in the Gunpowder Plot was 'The Gardener's Labyrinth'. Both versions of the miniature seem to have been painted when he was about thirty, c. 1595. James I had a miniature of Northumberland by Nicholas Hilliard but it is not known whether it was one of those described here.

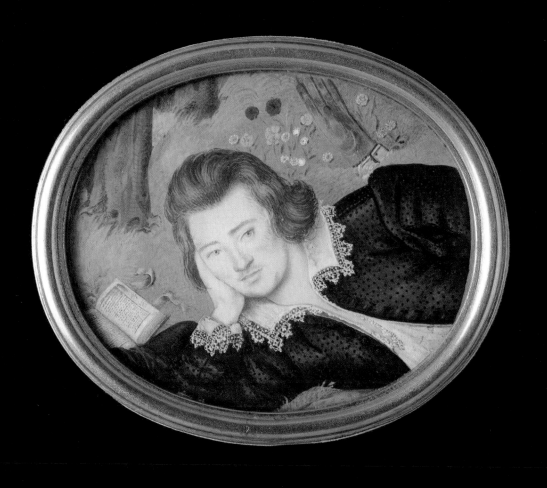

# 8

# NICHOLAS HILLIARD

—

AN UNKNOWN LADY

*Vellum laid on card. Rectangular. $7^1/_8 \times 4^7/_8$ in. $182 \times 122$ mm.*
PD.209–1961. BP, p. 117.

From the time of its origins with Horenbout and Holbein the portrait mini-
ature was usually circular or oval in shape and small enough to be held in the
hand or worn as an intimate token in a locket. During the 1580s Hilliard some-
times departed from this practice by producing larger miniatures, generally
rectangular, which would be shown on a wall or table like a conventional oil
portrait. These are known as 'cabinet miniatures'. Amidst some half-dozen
such miniatures by Hilliard the present one is the only representation of a lady,
and it has remained unfinished. Thereby it gives a valuable insight into
Hilliard's method of working, and demonstrates the assurance with which he
lays in the preliminary lines of his composition with a neutral tint. He
describes some preliminaries in 'The Arte of Limning'. The first line must be
the outline of the forehead, since it determines the scale of the whole and
establishes the position to which the sitter must return if he should move. 'The
eye is the life of the picture', and the circle of the sight must be a perfect round.
Although unsystematic his instructions are often precise: 'If you draw from
head to foot, let the party stand at least six yards from you'; 'Tell not a body
when you draw the hands, but when you spy a good grace in them take it
quickly . . . when they are told they give the hand the worse and more unnatural
or affected grace.' This is a magnificent illustration of the formative stages of a
Hilliard miniature of the most ambitious kind.

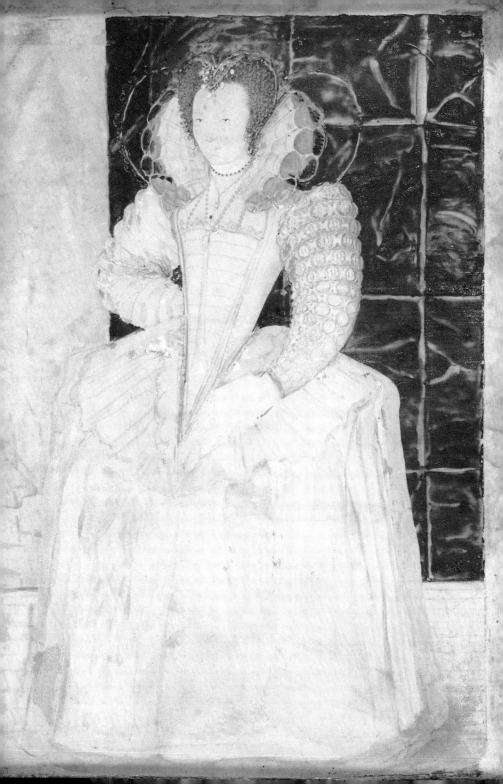

# NICHOLAS HILLIARD

—

QUEEN ANNE OF DENMARK (1574–1619).
*Vellum laid on playing-card (one club visible). Oval. 2¹/₈ × 1³/₄ in.*
*54 × 43 mm. In an enamelled gold frame set with table diamonds.*
*The monograms are those of Anne, her mother Sophia and her*
*brother Charles IV of Denmark.*
*No. 3855. BP, pp. 118–19.*

Hilliard was in his mid-fifties when James I succeeded to the throne. This event had a marked effect upon his fortunes. He was confirmed in office as the King's Limner, but no longer had the friendly relationship with the Court which he had enjoyed under Elizabeth I. The King was not particularly interested in the visual arts, and the lead in matters of taste was taken by his Queen, Anne of Denmark and in due course by her son Henry Frederick, Prince of Wales. They preferred the more up-to-date and Continental style of Hilliard's pupil and rival Isaac Oliver. In his personal commissions for private patrons Hilliard was still capable of reviving the poetry of his earlier days. But his official commissions evidently gave him little enthusiasm. He was obliged to produce many standard images of James I and his family, both as miniatures and as gold medals. The uninspired quality of these court portraits suggests that he did not take much interest in them, and he no doubt employed assistants, particularly his son Laurence, on their production. The present miniature is the most accomplished of Hilliard's miniatures of Queen Anne of Denmark. Although it is arid in manner it preserves some features of his more expressive style. In particular the drawing of the hand and the relief accorded to the jewels are consistent with Hilliard's own authorship.

A painting of Lady Anne Livingston, Countess of Eglington, shows the miniature case tied to a ribbon bow-knot with a pendant pear-pearl beneath it. This has been associated with an item recorded as having been made by George Heriot, the Scottish jeweller, for Queen Anne in 1611. Lady Anne wears this above her heart and it is likely that Queen Anne gave it to her as a wedding present when she married in 1612.

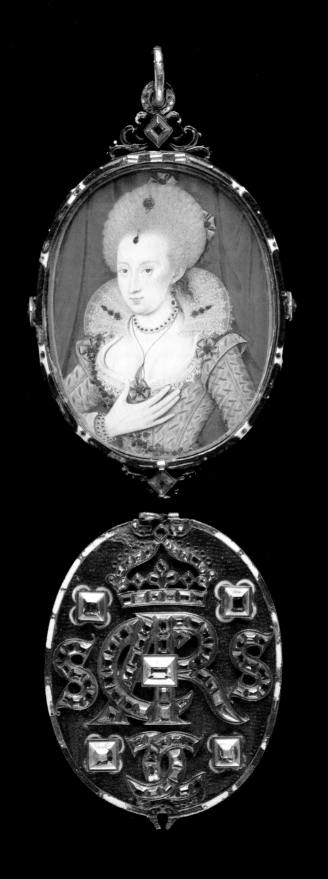

# ISAAC OLIVER (d. 1617)

—

(A) AN UNKNOWN MAN AGED 57 IN 1588 · TOP

Vellum. Oval, 2¹/₈ × 1³/₄ in. 54 × 49 mm. Inscribed in gold 'Anno Domini 1588
Æ Suae 57'. No. 3882. BP, pp. 65–6.

(B) AN UNKNOWN MAN · BOTTOM

Vellum. Oval. 1⁷/₈ × 1¹/₂ in. 49 × 39 mm. Signed in gold 'I.O' (monogram).
No. 3866. BP, p. 166.

(A) Isaac Oliver was the most eminent pupil of Nicholas Hilliard. He was the son of Pierre Oliver, who had been a goldsmith in Rouen and fled from religious persecution first to Geneva and then to England. The upper miniature is one of the earliest works by Isaac Oliver, painted soon after he had completed his training under Hilliard. This, with two other miniatures also dated 1588, marks his emergence as an independent artist, with a manner widely different from that of his master. Their artistic affinity is with Flemish art, though it is not known whether he travelled in the Low Countries at this time. He could have imbibed the sharper lighting and darker shadows by studying the prints of Goltzius, a course recommended by Hilliard. The strong Continental accent of the portrait has led to its ascription to the Dutch school. However, the main features of Oliver's handling are already apparent in this miniature: the tautly drawn hair, the dark cast shadows on the features, the smutty tones formed by the fusion of a multitude of stippled dots, and the inscription written in a more spindly version of Hilliard's flowing script.

(B) The lower miniature was probably painted some ten years later and may represent Sir Everard Digby (1578–1606) who was executed for his part in the Gunpowder Plot. It retains the same relentless realism in the portrayal of the sitter's features. Its severity contrasts with the more engaging character of such contemporary miniatures by Hilliard as nos. 5, 7 and 8. Hilliard extolled 'pleasing comely grace . . . because a sad and heavy countenance in a picture is a sign of some evil'.

# ISAAC OLIVER

—

(A) AN UNKNOWN LADY · TOP

*Vellum. Oval. 2³/₈ × 2 in. 60 × 50 mm. No. 3883.* BP, *p. 161.*

(B) LUDOVICK STUART, 2ND DUKE OF LENNOX
AND DUKE OF RICHMOND (1574–1624) · BOTTOM

*Vellum. Oval. 2 × 1¹/₂ in. 49 × 40 mm. No. 3869.* BP, *p. 162.*

(A) The miniature of a lady is another early work by Oliver, painted when he was emerging from his dependence on Hilliard's teaching and developing an individual vision of severe realism. The distinctive tall hat worn over a white cap is seen in two other early portraits of women by Oliver. One is his earliest known work, signed and dated 1587 and in the collection of the Duke of Buccleuch; the other is in the collections of the House of Orange-Nassau.

Isaac Oliver visited Venice in 1596 and on his return the uncompromising severity of his style, based on northern European models, was modified by traces of an Italian influence. Thereafter his portraits are softer and some-times even *sfumato* in handling as in the lower miniature here.

(B) Ludovick Stuart, Duke of Lennox, was appointed to the order of the Garter, of which he is seen wearing the Ribbon, in 1603. He had been closely associ-ated with the promotion of the claims of his cousin James VI of Scotland to the English throne. He followed him to London on his accession and was given many important offices, including that of Steward of the Household, and was created Duke of Richmond in 1623, the year before his death.

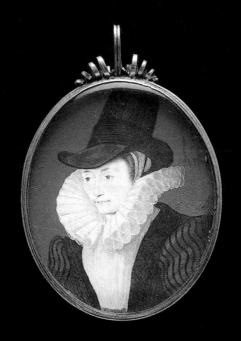

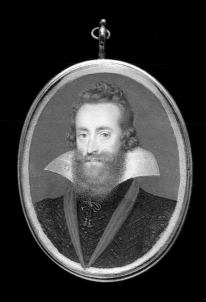

# ISAAC OLIVER

⌐

LUCY HARINGTON, COUNTESS OF BEDFORD (d. 1627)
*Vellum. Circular. 5 in. 127 mm. diameter.*
*No. 3902. BP, p. 165.*

This impressive miniature is one of Oliver's largest and most ambitious single portraits. There is a companion work in the Victoria and Albert Museum, also a large roundel, which is described as a portrait of Frances Howard, Countess of Essex. There has been much debate about the sitter represented here. She has been traditionally described as Lucy Harington, Countess of Bedford, and comparison with the accepted portraits of that lady at Woburn and Gripsholm suggests that this is probably correct. Embroidery in the late sixteenth and early seventeenth centuries reflects the fresh, almost naive, delight taken by the Elizabethans and Jacobeans in the natural world of fruit, flowers and insects. This enthusiasm is amply indulged in the sitter's dress and has been reproduced with meticulous care by Oliver, fitting with great decorative effect into the circular format and giving the portrait colour and vivacity.

It has been suggested that this representation is associated with Lucy Harington's appearance in the masque 'Hymenaei' performed at the marriage of Frances Howard to her first husband, the 3rd Earl of Essex, in 1606. Lucy was the daughter of John, 1st Lord Harington of Exton, who had been the guardian of the Princess Elizabeth, later Queen of Bohemia.

Lucy was married in 1594 to Edward Russell, 3rd Earl of Bedford. She was a noted patroness of the poets. John Donne, George Chapman and Ben Jonson addressed poems to her.

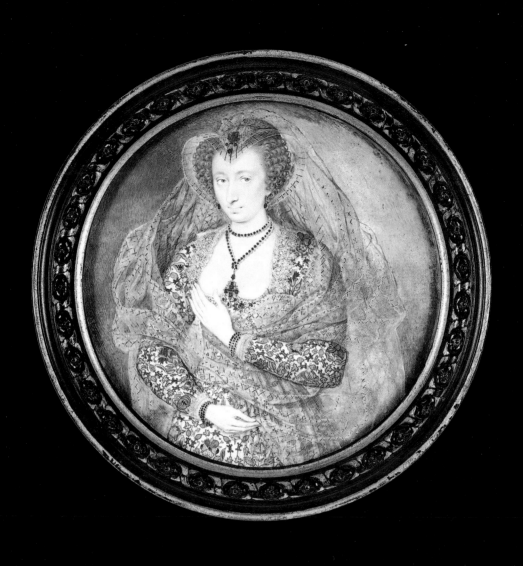

# ISAAC OLIVER

(A) HENRY FREDERICK,
PRINCE OF WALES (1594–1612) · TOP
*Vellum. Oval. 2¹/₈ × 1⁵/₈ in. 53 × 40 mm. Signed in gold 'I.O' (monogram).*
No. 3903. BP, pp. 166–7.

(B) RICHARD SACKVILLE,
3RD EARL OF DORSET (1589–1624) · BOTTOM
*Vellum. Oval. 1⁵/₈ × 1³/₈ in. 41 × 34 mm.*
No. 3865. BP, p. 167.

(A) The miniature of Henry Frederick, Prince of Wales in profile is probably the version which was owned by Charles I. This was described by Van der Doort in his catalogue of the King's collection as being 'after the old Roman fashion'. It was then in a turned ebony box. Oliver, who was the Prince of Wales's favourite miniaturist, has shown his patron as a Roman Emperor, in accord with the Jacobean monarchy's self-identification with Imperial Rome. By painting him in profile Oliver is reverting to a long-established practice, set by classical coins and medals and revived in manuscript illumination at the beginning of the sixteenth century.

(B) The portrait of Richard Sackville, Earl of Dorset is a head and shoulders version of a much more elaborate full-length cabinet miniature of him in the Victoria and Albert Museum. The larger portrait shows him standing on a fine Turkey carpet and wearing lavishly embroidered doublet and hose, the magnificence of which justifies his reputation as a reckless spendthrift. It is dated 1616, and this smaller version was probably also painted then, in the year before Oliver's death. Sackville's wife, Anne Clifford, kept a diary in which there is much evidence of his gambling and extravagance. He was heavily in debt when he died at the age of thirty-five in 1624, and Knole had to be mortgaged to pay his creditors.

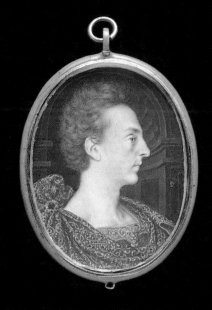

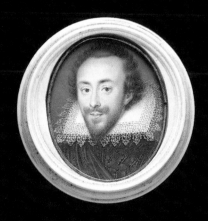

# PETER OLIVER (c. 1594–1647)

—

## AN UNKNOWN MAN, 1620
*Vellum. Oval. 2³/₈ × 2 in. 61 × 49 mm. Signed and dated in gold*
*'P O / 1620'. No. 3874. BP, p. 171.*

In the will he made shortly before his death in 1617 Isaac Oliver recognised his
son Peter Oliver as his successor in limning. Independent *ad vivum* miniature
portraits by him are however mainly confined to the next ten years, during
which he practised in a delicately varied version of his father's later, *sfumato*
manner. Much of his output consisted of repetitions of standard images of
Charles I, Frederick, King of Bohemia and Elizabeth, Queen of Bohemia.
During this period he ensured a continuation of the tradition established by
his father by giving instruction to Alexander Cooper, the younger brother of
Samuel Cooper. After the 1620s his energies were largely taken up by a series
of commissions from Charles I for small limned copies of Venetian paintings
in the Royal Collection and elsewhere. This diversion into compositions with
many figures was in accord with his father's ambitions, but would have been
thoroughly disapproved by Nicholas Hilliard, who wrote 'But of all things, the
perfection is to imitate the face of mankind (or the hardest part of it, and which
carrieth most praise and commendations and which indeed one should not
attempt until he were meetly good in story work).' Peter Oliver reversed this
order of events by first imitating the face of mankind, and then concentrating
on 'story work', and even in that he was copying other artists' inventions.

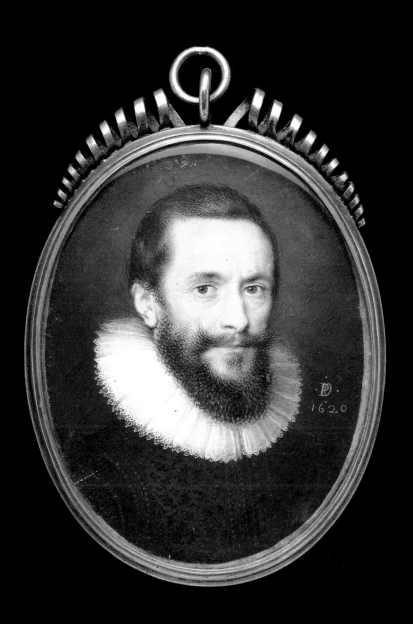

# PETER OLIVER

—

(A) HENRY WRIOTHESLEY,
3RD EARL OF SOUTHAMPTON (1573–1624) · TOP
*Vellum. Oval. 2¹/₈ × 1³/₄ in. 53 × 43 mm. Signed in gold 'P.O.'.*
*No. 3873. BP, pp. 170–1.*

(B) SIR KENELM DIGBY (1603–1665) · BOTTOM
*Vellum. Oval. 2¹/₈ × 1³/₄ in. 53 × 43 mm. Signed and dated in gold*
*'1619 / PO'. PD.12–1955. BP, pp. 172–3.*

(A) The portrait of Southampton was painted some twenty-five years later than Hilliard's romantic representation of him as a young man (no. 4). It records the sobering effects of those years, during which he had narrowly escaped execution as a supposed supporter of Essex's plot against Queen Elizabeth I.

(B) Sir Kenelm Digby had entered Gloucester Hall, Oxford as a Gentleman Commoner in 1618, the year before this portrait was painted. He then travelled in the entourage of Prince Charles. He was a long-standing patron of Peter Oliver, who painted a number of miniatures of his wife Venetia Stanley, including one of her on her deathbed. But these, like a large family group, were limned copies of oils by Van Dyck.

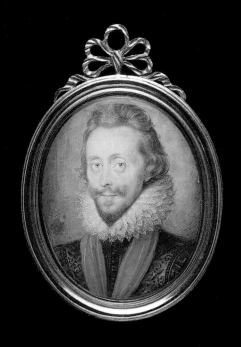

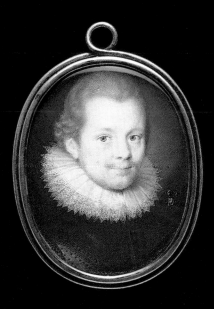

# LAURENCE HILLIARD (1582–1648)

AN UNKNOWN MAN, 1640

*Vellum laid on gessoed card. Oval. 2¹/₄ × 1³/₄ in. 58 × 43 mm.*
*Signed and dated in gold 'LH Ano Dni 1640 Ætatis Suae . . .'.*
*No. 3849. BP, p. 108.*

Laurence Hilliard was the only one of Nicholas Hilliard's seven children to follow his father's profession. He practised as a goldsmith and limner, and succeeded his father as King's Limner in 1619. Nicholas Hilliard did what he could to further his son's career by enlisting the support of Sir Robert Cecil when applying for appointments at Court. Much of Laurence Hilliard's work as a limner consisted in assisting his father to multiply routine images of James I. In his capacity as a goldsmith he made gold medals of Queen Anne of Denmark. Portraits of private individuals by him are rare. Those which are known do not display the interest in current taste which Peter Oliver showed in following his father's connection. The present miniature is one of his best works. The bronzed texture of the doublet is well rendered, and the red curtain background derives from his father's innovation, introduced into such miniatures as nos. 6, 8 above. The gold calligraphy is also based upon his father's, but with a less certain hand. The fact that this miniature was painted in the same decade as nos. 19 and 22A shows that Laurence Hilliard would have seemed out-of-date to the patrons of Hoskins and Cooper.

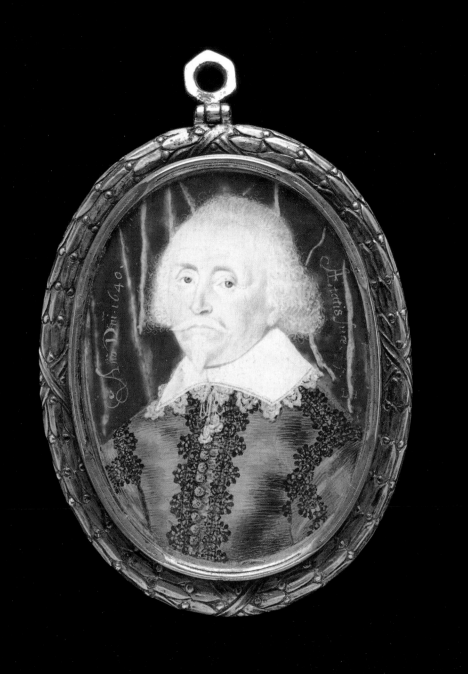

# SIR JAMES PALMER (1584–1657)

—

SIR PETER YOUNG

*Vellum. Oval. 2 × 1¹/₂ in. 51 × 38 mm.*
*Signed and dated in gold '1619 P'. Inscribed on the back*
*in a seventeenth century hand 'Sir Peter Young'.*
*No. 3877A. BP, p. 174.*

Castiglione had insisted in 'The Book of the Courtier' that the complete man should not neglect the art of painting. This led to its becoming a fashionable hobby in the late sixteenth and early seventeenth century. Nicholas Hilliard emphasised in his treatise 'The Arte of Limninge' that miniature painting is the branch of art 'fittest for gentlemen' since it can be pursued in private and is 'sweet and cleanly to use'. Of the amateurs who indulged in limning Sir James Palmer was especially accomplished, and achieved an almost professional standard. A man of wide culture, he advised Charles I on the formation of his collection of Old Masters. As this representative example of his painting shows, influences from both Hilliard and Oliver entered into the formation of his style. Indeed for a long time his signature P or JP in monogram was taken to be that of Peter Oliver.

The sitter, identified by the early inscription on the back, is taken to be the son of James I's Master Almoner, also Peter Young. He was sent on a diplomatic mission to the King of Sweden four years after this portrait was painted.

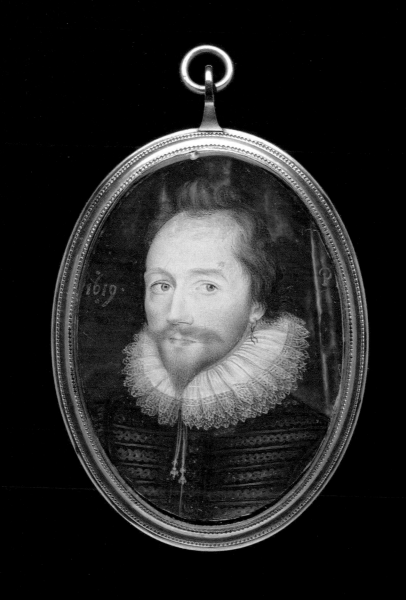

# DAVID DES GRANGES
## (1611– AFTER 1670)

—

(A) AN UNKNOWN MAN · TOP

*Vellum. Oval. 2¹/₄ × 1⁷/₈ in. 58 × 48 mm. Signed in gold 'D / D. G'.*
*In a turned ivory box. No. 3844. BP, p. 57.*

(B) AN UNKNOWN LADY · BOTTOM

*Vellum. Oval. 2³/₈ × 2 in. 62 × 51 mm. Signed in black 'D / D. G.'.*
*No. 3846. BP, p. 59.*

The demand for miniatures in the seventeenth century was high enough to engage a number of minor artists as well as the leading limners such as Hoskins and Cooper. David Des Granges is one of these artists of secondary talent. His first known miniatures date from c. 1630, but he achieved more prominence as a devoted servant of Charles II, whom he followed into exile. In the 1650s he was appointed King's Limner in Scotland. He has a wider renown as the author of the agreeably naive oil painting 'The Saltonstall Family' in the Tate Gallery.

Des Granges made an original contribution to the iconography of Charles II in exile, but the majority of his miniatures are copies or adaptations of oils by Van Dyck or of miniatures by Hoskins. However no originals for these two miniatures are known, and the identity of their sitters has not been established.

(A) The portrait of a man was painted c. 1640 before the Civil War disrupted Des Granges's work in London. It is in a turned ivory box, a standard method of framing in the seventeenth century.

(B) The delicately charming portrait of the girl was painted either in the 1650s, when Des Granges was in exile, or soon after the Restoration of Charles II in 1660.

# JOHN HOSKINS (d. 1665)

—

THREE CHILDREN OF KING CHARLES I:
PRINCESS ELIZABETH (1635–1650), JAMES, DUKE OF YORK
(1633–1701), HENRY, DUKE OF GLOUCESTER (1639–1660)
*Vellum. Rectangular. 3¹/₈ × 4³/₄ in. 80 × 119 mm.*
No. 3877. BP, pp. 131–2.

It fell to John Hoskins to adapt British miniature painting from the linear and insular approach of Nicholas Hilliard to the Continental sophistication of Van Dyck. Having been brought up as a painter in oils his first miniatures, produced from about 1615, display a nice fusion of the styles of Hilliard and Oliver. After the advent of Van Dyck in England in 1632 Hoskins changed his manner to assimilate the new style. He had amongst his pupils his orphaned nephews Samuel and Alexander Cooper, and these and other assistants contribute variety to the works he signed in the 1630s. In 1640 Charles I granted him an annuity of £200 a year as King's Limner. His commissions for the King often consisted of copying Van Dyck's portraits in miniature; but he did also make original portraits for him. This is one of two miniatures made in the 1640s in which he portrayed *ad vivum* the younger members of the Royal family. It is less comprehensive than a large sheet in the collection of the House of Orange-Nassau which has separate portraits of the King, Queen and all five of their children, painted about 1641. This, painted some six years later, shows James, Duke of York, at the age of about fourteen, Elizabeth at the age of twelve and Henry at the age of eight. At this time the children were in the care of the Duke of Northumberland. Elizabeth died at the age of fifteen, her death hastened it is said by grief at her father's execution. After a career as a soldier Henry died at the age of twenty-one in the year of the Restoration. The miniature is painted with refinement in Hoskins's individual manner: the lighting of the hair and the delicate rendering of the costumes is particularly noteworthy.

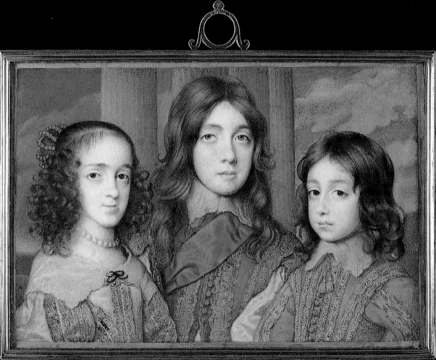

# JOHN HOSKINS

—

(A) ANTHONY ASHLEY COOPER
1ST EARL OF SHAFTESBURY (1621–1683) · TOP
Vellum. Oval. 2⅝ × 2 in. 67 × 52 mm. Signed and dated in gold
'1652 / I.H.'. No. 3861, BP, pp. 132–3.

(B) A MAN AGED 67 IN 1658 · BOTTOM
Vellum. Oval. 2⅞ × 2¼ in. 72 × 59 mm. Signed and dated in gold
'AETA 67 / 1658/ IH:'. No. 3859, BP, p. 133.

(A) The upper miniature descended in the sitter's family to the 7th Earl of Shaftesbury, and is the earliest known portrait of the statesman. When this portrait was painted Shaftesbury was a leading supporter of Cromwell and the parliamentary party. On the accession of Charles II he gained the King's favour, becoming Chancellor of the Exchequer and subsequently Lord Chancellor. The influential role he took in affairs of state had led to his being described as the first modern politician, foreshadowing 'the modern dema-gogue, the modern party leader, and the modern Parliamentary debater'. He was the founder of the Whig party. Dryden, who detested his attempt to exclude James II from succession to the throne, satirised him in 'Absolom and Achitophel'.

(B) The lower miniature had been described as a portrait of Sir Edward Nicholas, but this is not a tenable identification. It shows Hoskins in a mood responsive to the austerity of Commonwealth society.

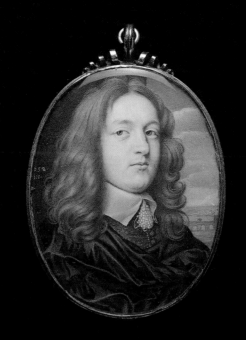

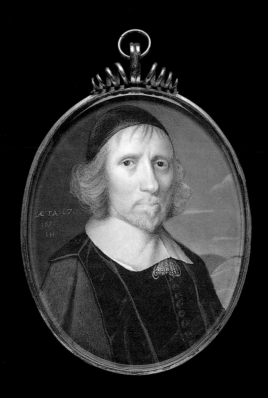

# JOHN HOSKINS

—

(A) AN UNKNOWN MAN, 1659 · TOP
*Vellum. Oval. 2³/₈ × 2 in. 60 × 49 mm. Signed and dated in gold*
*'1659 / I.H'. No. 3864.* BP, p. 133.

(B) ALGERNON SIDNEY (1622–1683), 1659 · BOTTOM
*Velllum. Oval. 2³/₈ × 2 in. 64 × 51 mm. Signed and dated in gold*
*'1659 / I.H:'. No. 3901,* BP, p. 134.

These two miniatures were painted in the last decade of Hoskins's life, at a time when his former predominance had been overtaken by the rise in fame of his nephew and pupil Samuel Cooper. They demonstrate that he had preserved his own individuality in their rather douce assessment of character. His style is a personal modification of the style naturalised in England by Van Dyck and Lely.

(A) The landscape background of the top miniature is a device frequently introduced by Hoskins, and variations can be seen in nos. 19 and 20A.

(B) The lower portrait represents Algernon Sidney, who was executed for his part in the Rye House plot to assassinate Charles II in 1683. His republican views earned him a posthumous reputation with both the French and American revolutionaries and his picture was displayed by the Jacobins. The portrait of Sidney by Justus van Egmont at Penshurst shows him with a pronounced double chin and warts. Unlike Cooper, who complied with Cromwell's demand that he show 'all these ruffness, pimples, warts & everything as you see me', Hoskins did not fully express all these defects.

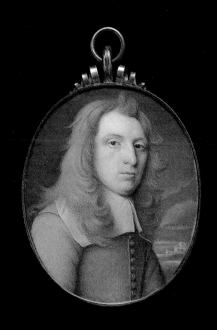

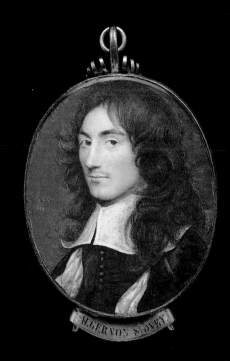

# SAMUEL COOPER (1608–1672)

—

(A) MRS ELIZABETH LEIGH, 1648 · TOP

*Vellum. Oval. 2³/₄ × 2¹/₈ in. 70 × 55 mm. Signed in gold 'S C / 1648'.*

*No. 3787. BP, p. 33.*

(B) AN UNKNOWN MAN · BOTTOM

*Vellum. Oval. 2¹/₈ × 1⁵/₈ in. 54 × 42 mm. Signed in gold 'S C'.*

*PD.194–1961. BP, p. 34.*

Samuel Cooper was the elder son of John Hoskins's sister Barbara. As orphans he and his younger brother Alexander were placed under the care of their uncle and trained by him in miniature painting. Samuel Cooper continued to work in partnership with John Hoskins till he was thirty-four years old, when he married and set up his own practice. He was soon the leading miniaturist of his times, and was renowned throughout Europe. He seems not to have taken sides in the conflict of ideas and painted Cavaliers and Parliamentarians with equal penetration.

(A) The upper miniature has long been regarded as one of the outstanding female portraits by Samuel Cooper. It was made when Cooper was fully established in his independent career, and combines his strength of handling with his searching insight into character. Cooper left a large number of unfinished miniatures at his death, and their incompleteness led to the belief that he was not able to paint hands. The delicacy of the sitter's right hand holding her dress in this miniature shows that this assumption was unfounded. The lady has been found to be Elizabeth Graves, who married first Lord Audley and secondly Mr George Leigh.

(B) The lower miniature was at one time thought to be a portrait of John Thurloe, but does not resemble him. The sitter's armour indicates that he is a soldier engaged in the wars of that embattled period, c. 1650.

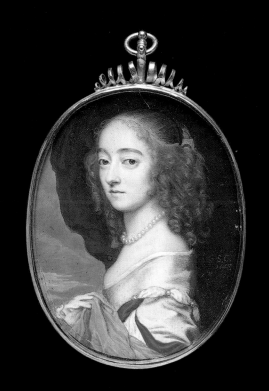

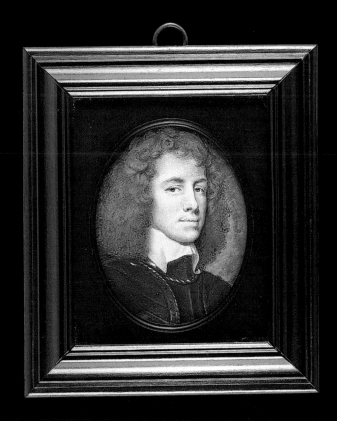

# SAMUEL COOPER

—

(A) ROBERT LILBURNE (1613–1665) · TOP
Vellum. Oval. 2¹/₈ × 1³/₄ in. 55 × 45 mm. Signed and dated in gold
'S C / 1650'. No. 3830. BP, p. 35.

(B) THE REV. THOMAS STAIRSMORE (d. 1706) · BOTTOM
Vellum. Oval. 2¹/₂ × 2 in. 62 × 49 mm. Signed and dated in gold
'1657 / SC' (monogram). No. 3928. BP, p. 37.

(A) The upper miniature represents the regicide Robert Lilburne, painted in the year before he served in Cromwell's Scottish campaigns. He held a number of important posts under the Commonwealth, including that of Governor of York, but was branded as a malcontent. He was condemned to life imprisonment on Charles II's return for his part in the execution of Charles I.

(B) The lower miniature is one of the earliest to enter the Museum, having been bequeathed in 1878. It provides a classic example of Cooper's ability to express rigid strength of character through the penetrating rendering of his sitter's features. The traditional description as the Rev. Thomas Stairsmore identifies him as the clergyman who became Vicar of Edmonton in 1680.

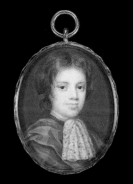

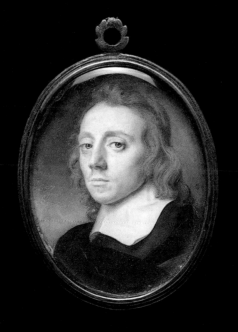

# SAMUEL COOPER

—

AN UNKNOWN MAN

*Vellum. Oval. 2⁷/₈ × 2³/₈ in. 74 × 59 mm. Signed in gold*
*'S.C.'(monogram). No. 3831, BP, pp. 38–9.*

During the Commonwealth Cooper worked for Cromwell and produced the most revealing portrait of the Protector. None the less, when Charles II was restored to the throne Cooper was immediately received into Court favour. Within a few days of his return the King sat to Cooper for his portrait. Later Cooper went on to make drawings of him for the coinage, and to make large sketches in miniature of the Queen and of the Royal mistresses. These are amongst his most remarkable achievements.

The present miniature was painted at about the period of the Restoration. It is representative of Cooper's work at that time in the sharply angled light-ing, which brings out the character of the face and provides the typical deep shadows under the eyes and on the cheek. The breadth of his brushwork in the features is in marked contrast to the finesse with which the hair is painted.

The miniature has long been regarded, like a replica in the Buccleuch collection, as a portrait of Milton, but this is not an acceptable identification.

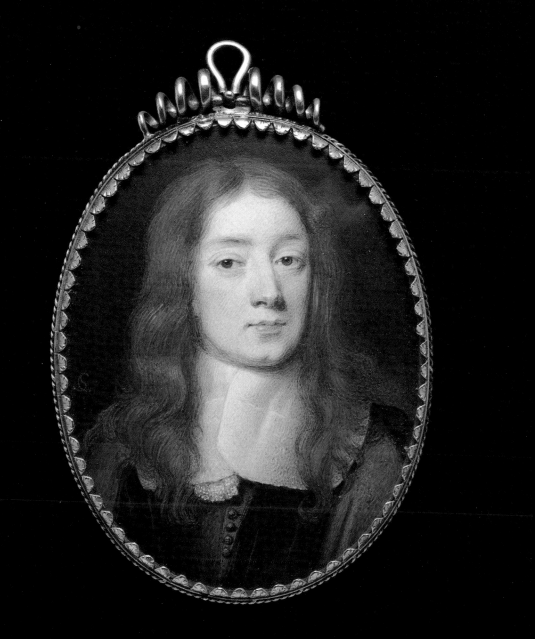

# SAMUEL COOPER

—

## AN UNKNOWN LADY

*Vellum. Oval. 2⅝ × 2¼ in. 67 × 55 mm.*
*Signed in black 'S.C.' monogram. No. 3826.* BP, p. 38.

It is instructive to compare this miniature with no. 22a. The latter was painted in 1648, at the height of the Puritan ascendancy and although Cooper has captured the charms of his sitter he has conveyed them with respectful reticence. In this later work, painted soon after 1660, the additional feminine allure which Cooper has imparted to his sitter reflects his response to the greater latitude in manners introduced by the Court of Charles II. The lady is wearing the coiffure known as 'Braganza curls' from the Portuguese fashion introduced by the Queen, Catherine of Braganza. This is one of many seventeenth century portraits of beguiling young beauties which have been called Lady Lucy Percy. Her notoriety has caused many such images to be given her name, but since she would have been over sixty years old when this miniature was painted it cannot represent her.

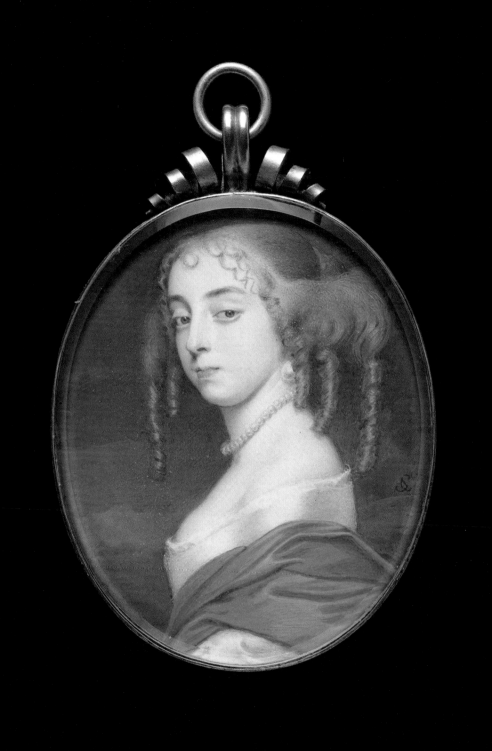

# NICHOLAS DIXON (c. 1645– AFTER 1707)

—

(A) AN UNKNOWN LADY, 1667 · TOP

Vellum. Oval. $2^3/_8 \times 2$ in. $59 \times 49$ mm. Signed and dated in gold
'ND (monogram) / 1667'. PD.6–1949. BP, p. 60.

(B) AN UNKNOWN MAN · BOTTOM

Vellum. $2^3/_4 \times 2^1/_4$ in. $69 \times 58$ mm. Signed in gold
'ND' (monogram). No. 3835. BP, p. 61.

Nicholas Dixon succeeded Richard Gibson as King's Limner in 1673. His style has more in common with that of Hoskins. He had a less vivid sense of colour than Samuel Cooper, and his work is characterised by the mannerism which has become known as 'Dixon eyes'. These are elongated almond-shaped features gazing languorously at the spectator. In his portraits of women he is comparable with Lely in emphasising the sensuality of the Court ladies. His male portraits are more straightforward. Probably as a result of losing much of his practice after the death of Charles II in 1685, he resorted to speculation. He painted a large series of copies of Old Master paintings in miniature as one of the prizes in a lottery he had promoted, but this did not succeed.

(A) The upper miniature, which was painted in the early days of his career, was once in the celebrated collection of the American banker J. Pierpont Morgan. It was there described as a likeness of Francis Brooke, Lady Whitmore, but it does not resemble the portrait of her in Lely's The Beauties of Hampton Court.

(B) The portrait of a man was painted at much the same period as that of the lady. He is portrayed as a soldier with the gilt mask of a lion's head on the shoulder of his breast plate.

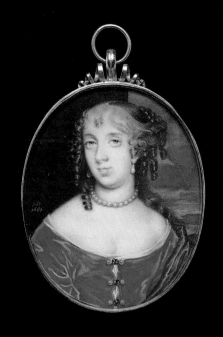

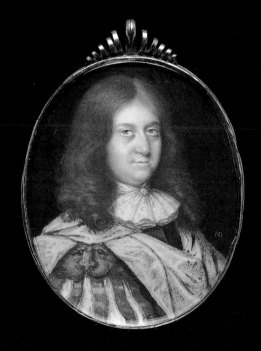

# NICHOLAS DIXON

—

CHARLES MIDDLETON,
2ND EARL OF MIDDLETON (?1640–1719)
*Vellum. Oval. 2⁷/₈ × 2¹/₄ in. 73 × 58 mm. Signed in gold*
*'ND' (monogram). No. 3789.* BP, *p. 61.*

Working on a larger scale than usual Dixon has here made a compelling portrait of one of the influential statesmen in the short reign of James II as King of England. Charles Middleton came from a long-established Scots family. His father, the first Earl, had supported Charles II during the Interregnum, and his son shared the Royal favour after the Restoration. He held the post of Secretary of State, and tried to modify James II's more disastrous policy decisions. He advised the King against fleeing from England in 1688, but stayed for some years in the country as a moderate Jacobite. However he joined James II in France in 1693. He was described by a contemporary as a 'black man, of a middle stature, with a sanguine complexion' and is further said to have been noted for his polished manners and learning. This portrait was made at the time when James as Duke of York was protecting his succession to the throne with Middleton's support.

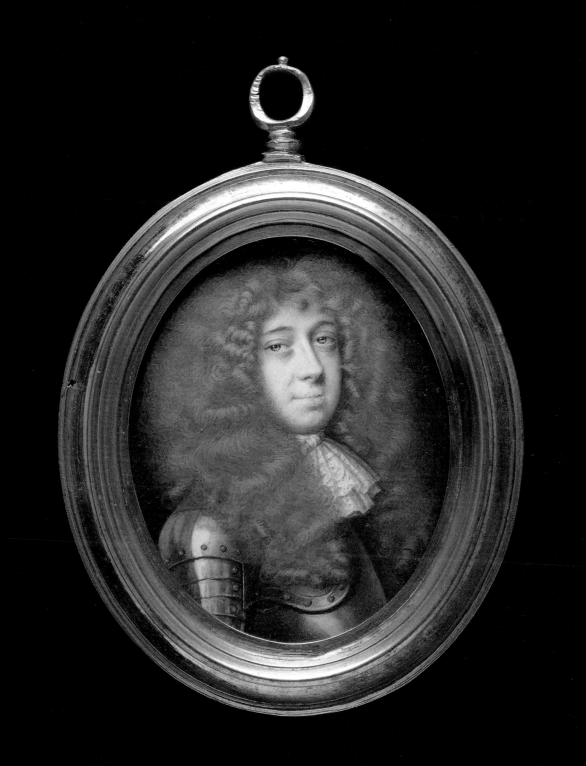

# THOMAS FLATMAN
## (1635–1688)

◆

THE REV. SAMUEL WOODFORDE (1636–1701)

*Vellum. 2³/₄ × 2¹/₈ in. 69 × 54 mm. Signed and dated in gold 'F / 1661'.
A damaged label fixed to the gessoed back of the miniature is inscribed by the
artist 'Amico suo fedeli /[S]amueli Wood[for]de/ hanc sui Effig[ie]/......./
Thomas Flatman /[Dec]emb. 1661'. No. 3842. BP, p. 84.*

Thomas Flatman was the most successful follower of Samuel Cooper. He was unusually versatile even for an age of polymaths, qualifying for the Bar and becoming a well-regarded minor poet, whose works are collected by Professor Saintsbury in *Caroline Poets*. He was closely associated with Mary Beale the portrait painter and her husband Charles.

Samuel Woodforde was also a man of versatile achievement. He too studied for the Bar, and in 1658 he shared chambers in the Inner Temple with Flatman. Through their friendship Woodforde met Beale's daughter Alice, whom he married in 1661, the year in which Flatman painted this portrait. He gave up the law for the Church, and was elected a Fellow of the Royal Society in 1664. Flatman was himself elected a Fellow of the Royal Society in 1668.

Owing to a misinterpretation of the inscription on the back this miniature was until recently thought to be a self-portrait. Flatman's authentic self-portrait, a later and far more penetrating study in melancholy, is in the Victoria and Albert Museum.

This miniature is one of Flatman's earliest known works. Woodforde wrote a poem about it addressed 'To Clelia on his own Picture done in Water-colours by the Learned Poet and Limner Mr Thomas Flatman.'

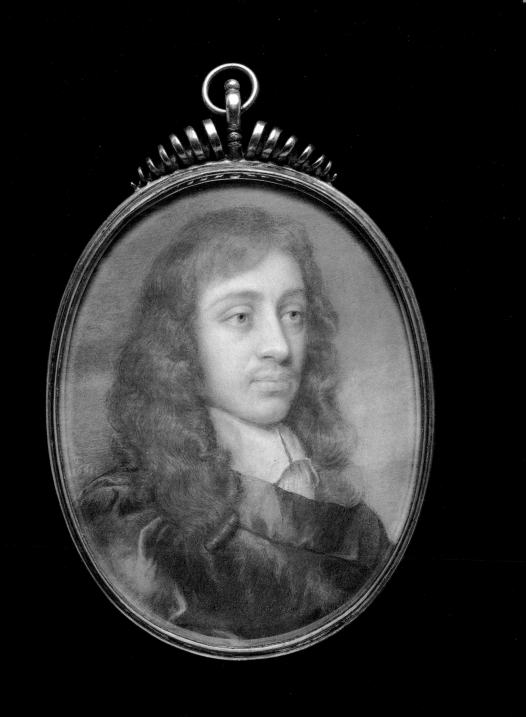

# RICHARD GIBSON (1615–1690)

ELIZABETH CAPELL, COUNTESS OF CARNARVON (1633–1678)

*Vellum. Oval. 3¹/₄ × 2⁵/₈ in. 84 × 67 mm. No. 3912. BP, p. 97.*

Richard Gibson was a dwarf, originally employed as a servant by Lord Pembroke, the Lord Chamberlain, and subsequently at the court of Charles I. His talents as a limner were recognised and his career extended through four reigns. His bride was also a dwarf, chosen for him by Charles I. The couple had four children of normal stature, one of whom, Susan Penelope, was herself a limner (see no. 30A). He enjoyed a close association with Peter Lely, who painted a double portrait of Gibson and his wife. On the death of Samuel Cooper in 1672 he became King's Limner for a year, being succeeded by Nicholas Dixon in 1673.

This is one of many portraits Gibson painted of members of the Dormer family. Elizabeth Capell married Charles Dormer, 2nd Earl of Carnarvon, in or before 1653, and this miniature was painted soon afterwards.

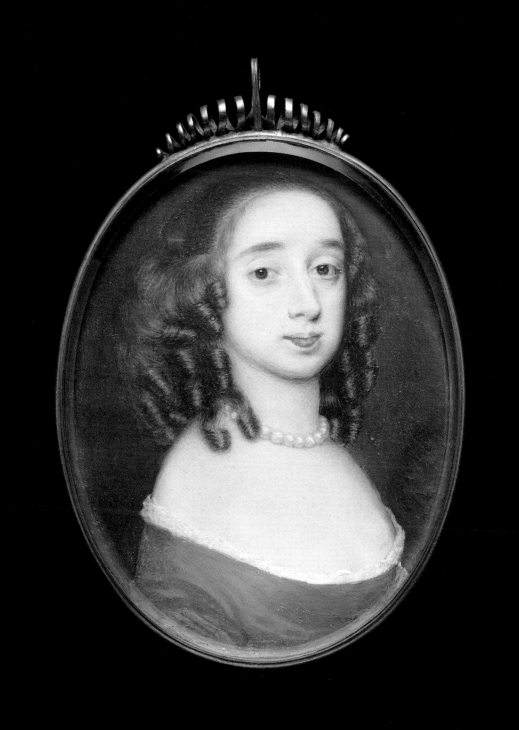

# SUSAN PENELOPE ROSSE, NÉE GIBSON
## (c. 1652–1700)

(A) AN UNKNOWN BOY · TOP

*Vellum. Oval. 1⅝ × ⅞ in. Signed in gold 'S.R.'. No. 3878, BP, p. 191.*

—

# PETER CROSSE (c. 1654–1724)

(B) MARY OF MODENA (1658–1718) · BOTTOM

*Vellum. Oval. 3¼ × 2⅝ in. 82 × 67 mm. Signed and dated in gold
'PC 1677'. No. 3833. BP, p. 52.*

(A) The upper miniature is the work of Richard Gibson's daughter Susan Penelope (see no. 29). Although taught by her father she modelled her style on Samuel Cooper, whose works she often copied. She frequently worked on the small scale of this example, in which she has achieved an engaging simplicity.

(B) The lower miniature is by Peter Crosse, whose identity as a miniature painter has only recently been unravelled. His later works are signed with a monogram 'P.C.' written in such a way that it was interpreted as 'L.C.' and assigned to a hypothetical 'Laurence Crosse'. His substantial body of work makes it clear that Crosse was the last English miniature painter to carry the seventeenth-century tradition into the first quarter of the eighteenth century. His *pointilliste* stippling and his retention of vellum as a support were to become old fashioned by the end of his life. Although much of his portraiture is *ad vivum* he was also employed to paint copies of oils. This is derived from a painting by Lely of James II's second Queen, Mary of Modena.

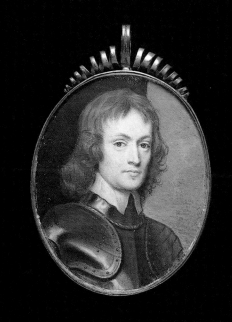

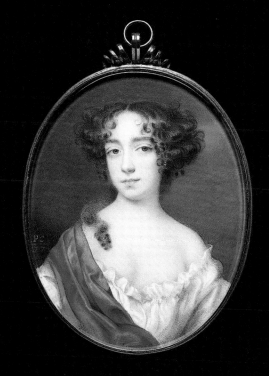

# RICHARD GIBSON

◦

ANNE HYDE, DUCHESS OF YORK (1637–1671)
*Vellum. Oval.* 3⁵/₈ × 2⁷/₈ in. 92 × 73 mm.
PD.206–1961, BP, p. 99.

Richard Gibson's style is marked by the pronounced stripes of raised pigment which lie in parallel lines across the features of his sitters. His individual technique is clearly exemplified in this miniature. Anne Hyde was the eldest daughter of Edward Hyde, Earl of Clarendon. An influential statesman at the Courts of Charles I and Charles II he told the story of his times in the *History of the Rebellion*. He wrote in his memoirs that he was greatly disturbed on hearing of his daughter's secret marriage to James, Duke of York: 'He broke out into a very immoderate passion against the wickedness of his daughter and said with all imaginable earnestness "that as soon as she came home he would turn her out of his house as a strumpet to shift for herself and would never see her again".'

The two surviving children of this marriage were Mary and Anne, both later queens of England. Gibson was appointed as their drawing-master, and followed Mary to The Hague on her marriage in 1677 to William Prince of Orange, later King William III of England.

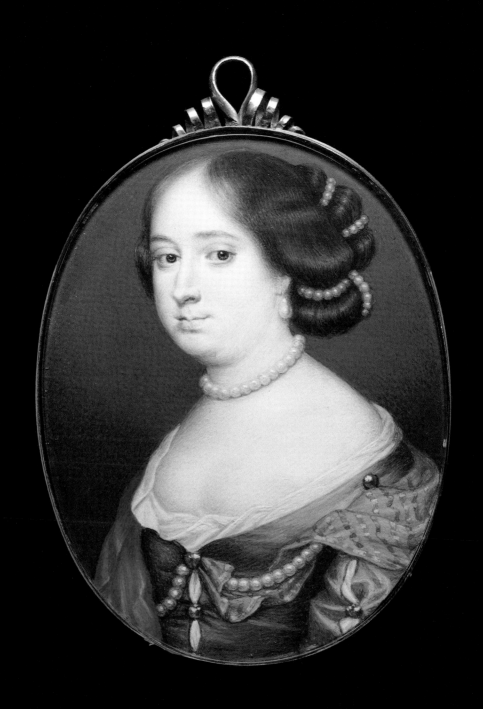

# PETER CROSSE

—

CHRISTOPHER MONCK,
2ND DUKE OF ALBEMARLE (1653–1688)

*Vellum. Rectangular. 4 × 3¹/8 in. 102 × 81 mm. Signed and dated in black
'P.C (monogram) / 1680'. Inscribed on the gessoed back by the artist 'This was
begun ye 4 / September 1680 at / Whitehall / Duke of Albermarle'.*
PD.204–1961. BP, p.53.

Christopher Monck was the only surviving son of George Monck, who had been created Duke of Albemarle for the crucial role he had played in the restoration of Charles II. In 1682 the sitter replaced Monmouth as Chancellor of the University of Cambridge. He raised the militia of Devon and Cornwall against Monmouth in 1685. In 1687 he was appointed Governor-General of Jamaica but died in the following year. The physician who attended him was Sir Hans Sloane, who described him as 'of a sanguine complexion, his face reddish and eyes yellow, as also his skin, and accustomed by being at court to sitting up late and often being merry'. His end does in effect seem to have been hastened by intemperance.

Albemarle is seen here with the Ribbon of the Order of the Garter, to which he was elected on his father's death in 1670. The inscription on the back of the miniature indicates that it was painted *ad vivum* in the Duke's apartments in Whitehall Palace.

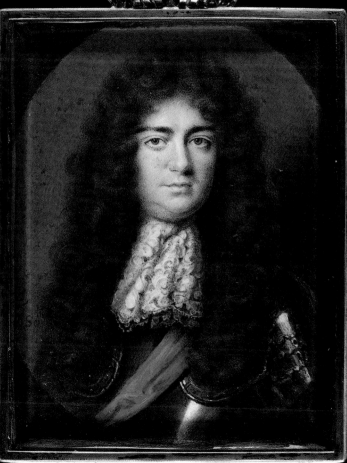

# 33

# CHARLES BOIT (1662–1727)

JOHN MANNERS,

2ND DUKE OF RUTLAND (1676–1721)

Enamel. Rectangular. 4⅝ × 3¾ in. 117 × 87 mm. Signed
in the enamel 'C.Boit'. PD.42 1948. BP, pp. 9–10.

Up to this point the miniatures decribed in this Handbook have been painted in watercolour and bodycolour on vellum laid on card, in a continuation of the traditional methods of manuscript illumination. Although dependent upon the same type of rendering and sense of scale, this miniature is painted in enamel on a metal plate. This method produces a form of ceramic in which the pigments are fired at high temperatures. It was developed for portrait enamels during the seventeenth century, deriving from such earlier forms as enamelled jewellery and the decorative plaques of Limoges enamel. The most notable exponent of the technique was Jean Petitot who, after a short period in England, produced a multitude of images of Louis XIV and his courtiers which are of an unparallelled delicacy of touch. His success led to the process becoming more widely fashionable, but England was late to adopt its regular use, and the first specialist exponents in this country were recruited from the Continent. Charles Boit was born in Sweden and had a cosmopolitan career, working in Paris, Düsseldorf, Vienna and The Hague. He came to England in 1687 and formed a close association with his fellow-countryman Michael Dahl, who was much patronised for large-scale oil portraits. William III gave Boit the appointment of King's Enameller, a post of which he was the first holder.

John Manners was the son of the first Duke of Rutland by his third wife, Catherine Noel. He was appointed to the Order of the Garter in 1714, and this enamel must be one of the last painted by Boit in England, since the artist fled to France that year to escape his debts.

72

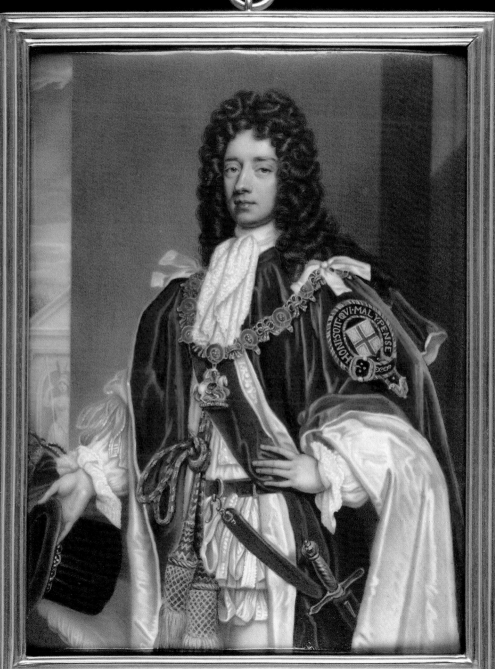

# BERNARD LENS (1682–1740)

—

## A LADY AS FLORA

*Ivory. Oval. 3 × 2¹/₄ in. 75 × 55 in. Signed in black 'BL' (monogram).
In a contemporary gilt-metal frame. No. 3918. BP, p. 149.*

In the early eighteenth century the use of enamel was acclimatised in England (see nos 33, 35). An equally radical change in miniature painting was produced by the substitution of ivory for vellum as the surface on which the work was painted. This practice was introduced by the Venetian artist Rosalba Carriera around the year 1696. Rosalba Carriera was a notable pastellist as well as miniaturist. She found that the luminous qualities which could be achieved by allowing the bright surface of the ivory to shine through the pigments gave her miniatures the lighter, more colourful qualities of pastel. In the earlier part of the eighteenth century the former dominance of vellum as a support was undermined both by the popularity of enamel and by the spread of ivory, which had swept the board by the second half of the century.

Bernard Lens was the first English artist to adopt this new medium, which he did within a decade of its introduction. He had a successful career as a fashionable drawing-master and succeeded Charles Boit as King's Enameller, though he did not produce any enamels. His talents were limited, but this miniature shows him at his colourful best. The decoration of the contemporary frame continues the symbolism of the miniature, in which the sitter is represented as Flora, the goddess of flowers.

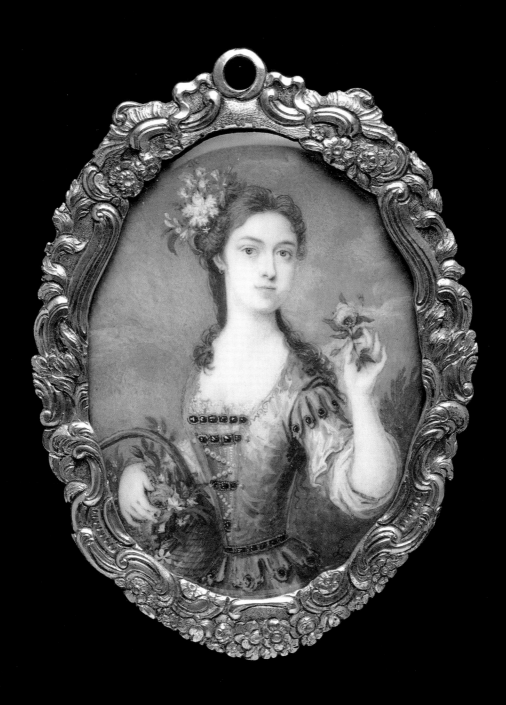

# CHRISTIAN FREDERICK ZINCKE
## (1684? – 1767)

(A) AN UNKNOWN YOUTH · TOP

Enamel. Oval. $2^5/8 \times 2^1/8$ in. $68 \times 54$ mm. Signed and dated on the back
'CF (monogram) Zincke, Fecit / 1716'. PD.7–1949. BP, pp. 212–13.

—

# JEAN ROUQUET (1701–1758)

(B) AN UNKNOWN MAN · BOTTOM

Enamel. Oval. $1^3/4 \times 1^1/2$ in. $45 \times 37$ mm. Signed in the enamel 'J.R.'.
In a gilt metal frame with the monogram ?WW surmounted by a coronet.
PD.51–1948. BP, p. 192.

(A) Christian Frederick Zincke was born in Dresden, the son of a goldsmith. He came to England in 1704 or 1706, at the invitation of Charles Boit, who taught him the art of enamelling. On Boit's withdrawal to France he became the leading miniaturist in England, and acquired a vast practice. He painted many portraits from life, but also made copies in little from Kneller and other contemporaries. The upper miniature once belonged to the celebrated collector of virtu, Horace Walpole. He regarded it as the artist's masterpiece, writing of it: 'The impassioned glow of sentiment, the eyes swimming with youth and tenderness, the natural fall of the long ringlets that flow around the unbottoned collar, are rendered with the most exquisite nature, and finished with elaborate care.' It is copied from a painting by Lely which was then regarded as a portrait of the poet Abraham Cowley, but this is not the case. It probably represents an Arcadian shepherd.

(B) Rouquet, who painted the lower enamel portrait, was born to French refugees in Geneva, and came to England around 1725. He was recognised at the time as the best of Zincke's rivals and his work has a softness and Gallic charm which reflects his French parentage. An observer of contemporaries' foibles, he satirised the search for new materials, such as coloured wax, in a treatise on the art of painting in cheese.

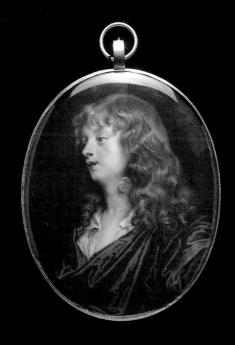

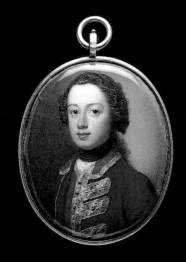

# GERVASE SPENCER (d. 1763)

•

*Ivory. Each Oval. 1¹/₄ × 1¹/₈ in. 31 × 27 mm. Each signed in brown*
*'G.S.' and framed as a wristband in gold set with pearls.*
*Nos. 3923, 3924. BP, p. 205.*

Gervase Spencer was in service as a footman when his talent for drawing was recognised. He was encouraged to make miniatures, and was trained both in enamel painting and in watercolour on ivory. It is believed that his sympathetic master was Dr Wall, who gave his name to the mid-eighteenth-century output of the Worcester porcelain factory. Spencer is one of the group of mid-eighteenth-century miniaturists who have become known as the 'modest school'. They worked on a small scale, well adapted to the current fashion of wearing miniature portraits mounted on bracelets round the wrist, as is the case with this pair of portraits. Whereas the portrait painting of the earlier part of the century had been dominated by Continental models, with the solemn style of Kneller as the main model, these mid-century miniaturists were more responsive to the traits of the national features. In this they were following the lead provided by Hogarth with his aggressive attempt to shake off foreign influences.

Spencer worked with unpretentious grace. This representative pair of miniatures on ivory no doubt represents a newly married couple. They are traditionally said to be Lord Torpichen and his wife. It is not however easy to fit this description with the known holders of that title, which was borne by members of the long established Scots family of Sandilands.

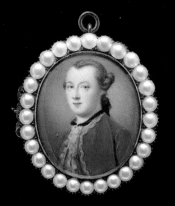
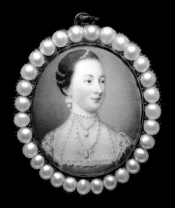

# NATHANIEL HONE, R.A. (1718–1784)

●

(A) AN UNKNOWN LADY, 1750 · TOP

Enamel. Oval. 1³/₄ × 1¹/₂ in. 45 × 37 mm. Signed and dated in black 'NH 1750'.
PD.44–1948. BP, p. 127.

(B) AN UNKNOWN LADY, 1749 · BOTTOM

Enamel. Oval. 1⁷/₈ × 1⁵/₈ in. 48 × 40 mm. Signed and dated
in black 'NH / 1749'. No. 3917. BP, p. 127.

Nathaniel Hone was born in Dublin, but worked from an early period in England as a portrait painter. Around 1750, when these two portraits were painted, his main practice lay in painting miniatures in enamel or on ivory, with the qualities of size and presentation associated with the 'modest school' (see no. 36). He subsequently pursued his ambition to succeed as a painter of large-scale portraits in oil, and in that capacity he was elected as one of the original members of the Royal Academy in 1768. He achieved notoriety in 1775 when he was asked to withdraw his painting *The Conjurer* which accused Sir Joshua Reynolds of plagiarism and, more tellingly, was believed by Angelica Kauffmann to lampoon her. In making his accusations against Reynolds Hone was able to draw on his very extensive knowledge of prints after the Old Masters.

Both these miniatures are enamels. The lady whose portrait at the top is wearing a species of historical costume which stems from the current fashion for being portrayed as Mary, Queen of Scots or some other sixteenth century figure.

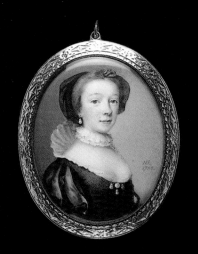

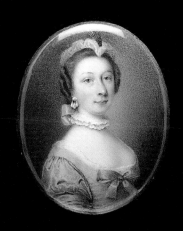

# THOMAS REDMOND (c. 1745–1785)

(A) AN UNKNOWN BOY · TOP

*Ivory. Oval. 1³/₄ × 1¹/₈ in. 38 × 30 mm. Signed in black 'TR'.*
*Mounted as a brooch in a gold frame set with half pearls.* PD.65–1948, BP. p. 187.

# SAMUEL COTES (1734–1818)

(B) AN UNKNOWN LADY · BOTTOM

*Ivory. Oval. 2 × 1¹/₂ in. 49 × 38 mm. Signed and dated in black*
*'S.Cotes/px 1766'. In a frame set with half pearls alternating*
*with garnets.* PD.59–1948. BP, pp. 49–50.

During the second half of the eighteenth century the growing demand for miniatures led to a number of artists setting up in centres other than London. Thomas Redmond, who painted the upper miniature, was one of those who were attracted to Bath, as Gainsborough had been, by the prospect of portraying members of the fashionable world who went there in search of health.

Samuel Cotes was the pupil of his brother Francis Cotes, whose portraits in oils were almost as highly regarded as those of Reynolds and Gainsborough, and who also worked in pastel. Samuel Cotes belonged to the period in which the simple wares of the 'modest school' began to lose ground to the larger and more expressive miniatures of Meyer and Cosway. The present example of his work shows him beginning to venture into the larger format which gave more scope for the study of character.

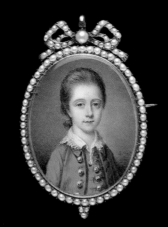

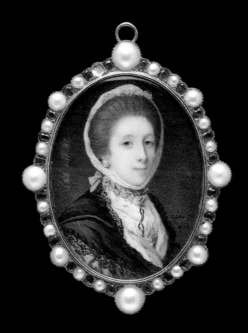

# JEREMIAH MEYER, R. A. (1735–1789)

AN UNKNOWN LADY

Ivory. Oval. 3³/₈ × 2⁷/₈ in. 89 × 72 mm. PD.18–1947. BP, pp. 156–7.

Jeremiah Meyer was born in Tübingen, where his father was portrait painter to the Duke of Wurttemberg. He was brought to England at the age of fourteen. In his early twenties he was given some tuition in enamel painting by the aging Zincke (see no. 35). He made enamels throughout his career, but more frequently in the earlier part of it. His claim to preeminence rests firmly on his miniatures in watercolour on ivory. These signal the new flowering of the English portrait miniature, which became established in the last three decades of the eighteenth century. In the 1770s Meyer extended the size of his miniatures beyond the 'two inches of ivory' which Jane Austen claimed as her domain, and this enlargement gave scope for the development of his individual talents as a draughtsman. The present example of his work on its larger scale was painted at the time when fashionable hair styles were being piled high above the head. Meyer relished the opportunity of depicting these often fantastic creations with a full enjoyment of their linear qualities. He was able to surround his sitters with more space in these larger ivories, to the advantage of his particular method.

Meyer was in high favour with the Royal family and painted portraits of George III and Queen Charlotte on the same scale as this portrait of an unknown lady. As a founder member of the Royal Academy in 1768 he was the only one chosen as a specialist in miniature painting; Nathaniel Hone (see no. 37), another founder member, was by then primarily a portrait painter in oils.

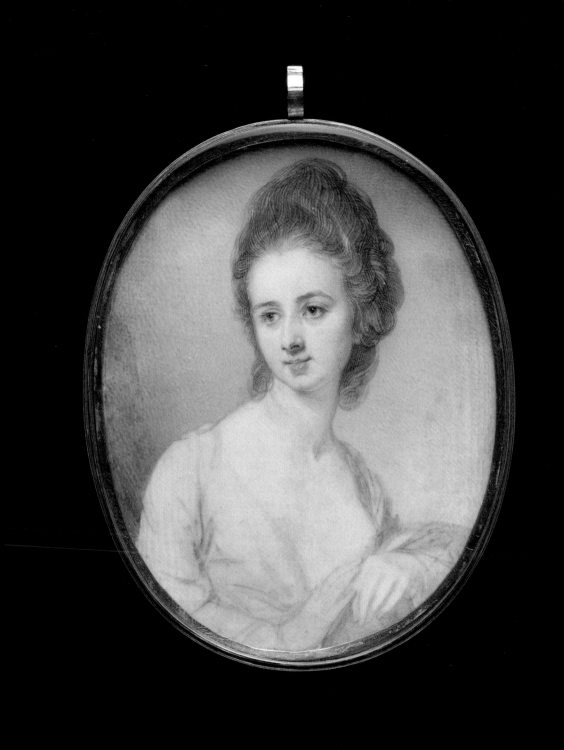

# JEREMIAH MEYER

—

(A) ELIZABETH MONTGOMERY (1751–1783) · TOP

*Ivory. Circular. 2$^1$/$_2$ in. 65 mm. diameter. Set in the lid of a circular gold box
with the maker's mark of Pierre François Mathis de Beaulieu, Paris.*
M.7–1959. BP, p. 156.

(B) MICHAEL FREDERICK
TRENCH OF HEYWOOD (1746–1836) · BOTTOM

*Ivory. Oval, 1$^1$/$_2$ × 1$^1$/$_4$ in. 38 × 31 mm.* PD.18–1955. BP, p. 157.

(A) The sitter in the upper miniature, Elizabeth Montgomery, was a famous beauty. The box in which this miniature is set was made in Paris in 1774, the year after her marriage at the age of twenty-two to Luke Gardiner. Her husband later became Viscount Mountjoy. As is often the case with Meyer's miniatures on ivory this portrait shows signs of fading, and this has diminished the sharpness of his rendering of the face.

(B) The lower miniature is traditionally described as a portrait of 'Trench of Heywood', which identifies him as Michael Frederick Trench. He was a member of a prominent Irish family in Queen's County, which included amongst its members the Earl of Clancarty. His son, Sir Frederick William Trench, projected the Thames Embankment and the colossal statue of Wellington which used to stand opposite Apsley House.

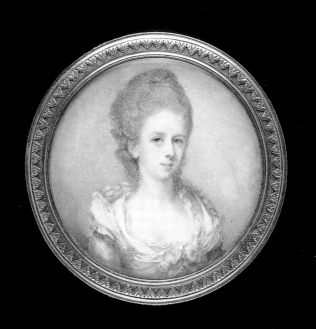

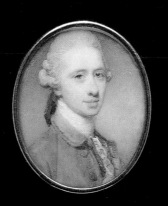

# JEREMIAH MEYER

—

(A) SIR THOMAS FRANKLAND, BART (1750–1831) · TOP

*Ivory. Oval. 1³/₄ × 1¹/₂ in. 45 × 36 mm. The gold frame, which is set with small pearls is engraved on the back 'Thomas/ Frankland Esq/ Aetat 24.*

*J.M. Pinxit /A.D. 1775'. PD.214–1961. BP, p. 157.*

(B) AN UNKNOWN MAN · BOTTOM

*Ivory. Oval, 1¹/₄ × 1¹/₄ in. 39 × 33 mm. PD.9–1962. BP, p. 158.*

Both these miniatures are in excellent condition, having escaped the fading to which so much of Meyer's work is subject. They provide an opportunity for the just appreciation of Meyer's abilities as a painter of male portraits. He was able to convey those qualities of elegance and aristocratic mien which were the models for deportment in the late eighteenth century. This reflects his own attractive character. Hayley, the friend of many artists (see no. 51), thought him the person who to his knowledge had been 'most instrumental in promoting the prosperity of others'. Carl Winter, who was Director of the Fitzwilliam Museum when these two miniatures were added to the collections, remarked that Meyer 'imported into English miniature painting an elegance akin to that of the fine porcelains of Meissen and Nymphenburg'.

The sitter in the upper miniature is Sir Thomas Frankland, who succeeded his father, Admiral Sir Thomas Frankland as 6th baronet in 1784. He became Member of Parliament for Thirsk and was High Sheriff of York in 1792. An eminent botanist, he was a member of the Linnean Society and a Fellow of the Royal Society. The genus *Franklandiae* is named after him.

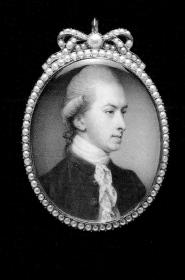
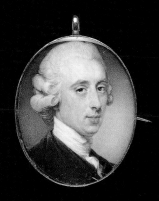

42

# RICHARD COSWAY, R.A.
## (1742–1821)

GEORGE IV (1762–1830) AS PRINCE OF WALES
*Ivory. Oval. 3¹/₈ × 2¹/₂ in. 79 × 65 mm.*
*No. 3752. BP, p. 41.*

Richard Cosway was confirmed in favour with the Prince of Wales in the early 1780s when his miniature portrait of Mrs Fitzherbert was highly approved. He was designated 'Principal Painter to his Royal Highness the Prince of Wales' in 1785 and thereafter frequently signed his miniatures on the back with the florid description 'Primarius Pictor Serenissimi Walliae Principis' (see no. 43a).

Cosway painted over thirty miniatures of his Royal patron, with many variations in poise and costume. One popular representation showed him in Cavalier dress as 'Prince Florizel'. This version shows him wearing the Hussar uniform of the 10th Light Dragoons (the Prince of Wales's Own). It may have been painted to commemorate his appointment as Colonel Commandant in 1793, a position of which he was extremely proud.

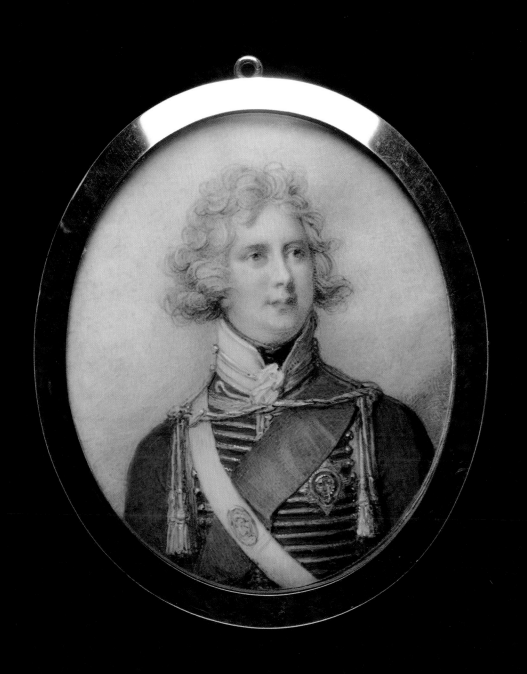

# 43

# RICHARD COSWAY

(A) CAPTAIN THE HON.
EDMUND PHIPPS (1760–1837) · TOP
*Ivory. Oval. 2 × 1³/₄ in 51 × 43 mm. Signed and dated on the back*
*'R:dus Cosway | R.A. | Primarius Pictor | Serenissimi Walliae |Principis|Pinxit|1788'.*
*The gold frame is engraved* 'CAPT THE HONBLE EDMUND PHIPPS,
1ST FOOT GUARDS. 1788 R.COSWAY, R.A. PINXIT'.
PD.198–1961. BP, p. 40.

(B) AN UNKNOWN OFFICER · BOTTOM
*Ivory. Oval. 1⁵/₈ × 1¹/₄ in. 41 × 31 mm.*
PD.197–1961. BP, p. 43.

The late eighteenth century was conspicuous for the finery of men's dress. The most colourful portraits are those of officers in their red military jackets. One resourceful miniaturist, Frederick Buck, had ivories prepared with red coats awaiting completion with the sitter's features and the insignia of his regiment, so that he could satisfy the demand for last-minute portraiture from the soldiers passing through Cork on their way to the Peninsula Wars. Cosway did not attempt such mass production. His portraits are fully expressive of the sitter's character.

(A) The top miniature represents Edmund Phipps, the fourth son of the 2nd Lord Mulgrave. He is shown in the uniform of a Captain of the 1st Regiment of Foot Guards. He rose to become a General and Colonel-Commandant of the 60th Foot.

(B) The sitter in the lower miniature, which was probably painted in the same decade, wears the uniform of an officer of the 1st (King's) Regiment of Dragoon Guards.

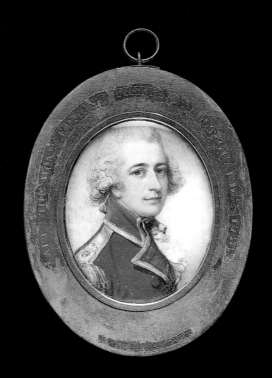
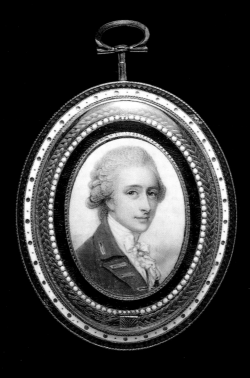

# RICHARD COSWAY

—

MARIA MAROWE, LADY EARDLEY (1743–1794).
Ivory. Oval. 3¹/₄ × 2¹/₂ in. 81 × 63 mm. In a gold frame set with
blue glass over foil and the initial 'E' in rose diamonds. The rim of the back
is inscribed 'From M.M.E. to her valued friend March 26th 1793'.
PD.202–1961. BP, p. 44.

Cosway was at the height of his renown in the last decade of the eighteenth century. He responded to this acclaim by maintaining a large size for his ivories and by limiting his palette to subtle tones of grey and blue. With the utmost economy of means he was able to give a convincing and complete presentation of his sitters. The reticence of his method caused the next generation of miniaturists, led by Andrew Robertson, to rebel against them as mere sketches and not fully realised paintings.

This miniature shows Lady Eardley at the age of fifty, and was painted in 1793, the year before her death. She was the daughter of Sir John Eardley Wilmot, a contemporary of Samuel Johnson at King Edward's School, Lichfield, who became Chief Justice of Common Pleas. In 1766 she married Sir Sampson Gideon (1745–1824), the son of the Government's chief financier. He took the surname of Eardley in 1789 and was created Lord Eardley in the Irish peerage in the same year.

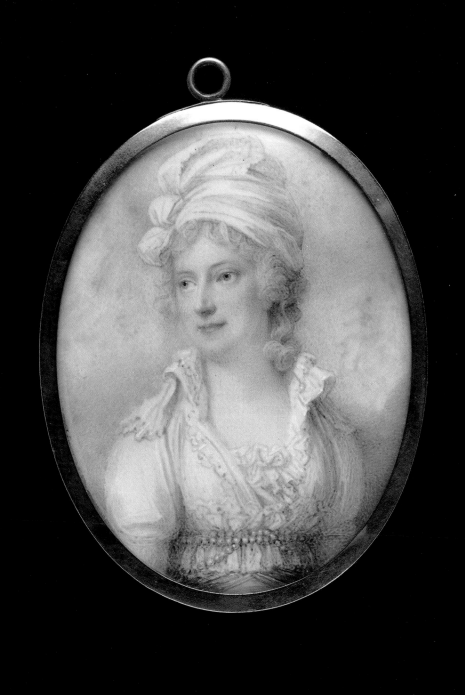

# RICHARD COSWAY

—

(A) SELF-PORTRAIT · TOP

Ivory. Oval. 2³/₈ × 2 in. 60 × 51 mm. PD.203–1961. BP, p. 46.

(B) A LADY OF THE SOTHEBY OR ISTED FAMILIES · BOTTOM

Ivory. Oval. 2¹/₂ × 2 in. 63 × 50 mm. PD.199–1961. BP, p. 44.

(A) Richard Cosway, who was ridiculed for his foppishness, portrayed himself in his earlier self-portraits as a macaroni in the height of extravagant fashion. The effect was unfortunate as he was short, dusky and, to many of his contemporaries, looked like a monkey. One such early portrait was caricatured with the inscription 'Dicky Causeway Ipse pinxt Tipsy Sculpt, in plain English'. At the end of the century, when he painted the self-portrait at the top of this plate he had less need to attract attention by such ostentation, and this example is notable for its restraint and the masculinity of its presentation.

(B) The lady in the second portrait is wearing the neo-classical dress which became fashionable in England around 1795. The miniature comes from a collection started at the beginning of the eighteenth century to which successive generations of Sothebys added till its dispersal in 1955. At that sale this miniature was described as a portrait of a member of the Sotheby or Isted families. William Sotheby (1757–1833), the author and friend of the Lake poets, married in 1780 Mary, daughter of Ambrose Isted, whose estates at Ecton, Northamptonshire were eventually inherited by the Sotheby family at the end of the nineteenth century.

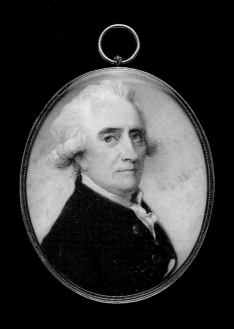

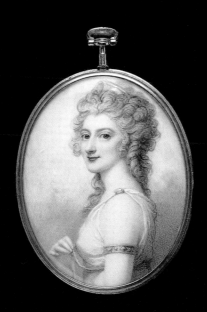

# JOHN SMART (1743–1811)

(A) AN UNKNOWN LADY, 1770 · TOP

Ivory. Oval. $1^5/8 \times 1^1/4$ in. $42 \times 31$ mm. Signed and dated in black
'J S / 1770'. PD.66–1948. BP, p. 199.

(B) AN UNKNOWN MAN, 1770 · BOTTOM

Ivory. Oval. $1^1/4 \times 1^1/4$ in. $33 \times 30$ mm. Signed and dated in black
'J S / 1770'. In a frame with, at the front, blue glass over foil surrounded
by two rings of paste diamonds, and at the back blue glass over
foil and a lock of hair. PD.67–1948. BP, p. 199.

Smart was an almost exact contemporary of Cosway but achieved prominence
through a totally different style of painting. Cosway's effects were achieved
with a linear style of delicate drawing in light tones. Smart relished the metic-
ulous expression of detail and produced something of the effect of enamel in
his portraits on ivory. Smart almost invariably signed and dated his mini-
atures, a practice which enables the course of his style to be followed for
some fifty years. During that time he preserved a remarkable uniformity of
manner, only enlarging the scale of his later miniatures in accordance with
the prevailing fashion. These two miniatures, painted when he was twenty-
seven years of age, are typical examples of the smaller work of his earlier years.

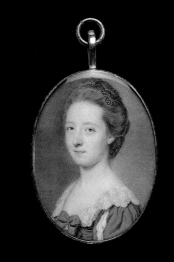

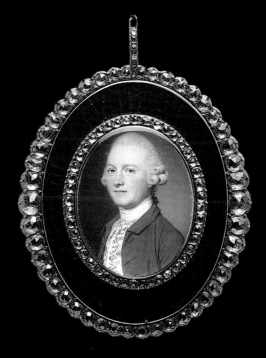

# JOHN SMART

(A) MAJOR SIR ALEXANDER ALLAN, BART (1764–1820) · TOP

*Ivory. Oval. 2¹/₈ × 1⁵/₈ in. 53 × 40 mm. Signed and dated in black 'J S / 1787/ I '.*
*The back of the gold frame is engraved 'Sir Alexr Allan Bt MP for Berwick Director of the*
*East India Company'. The central compartment of that back has plaited hair*
*and the monogram in gold 'A A'. No. 3881. BP, pp. 200–1.*

(B) AN UNKNOWN FRENCHMAN · BOTTOM

*Ivory. Oval. 2¹/₄ × 1³/₄ in. 58 × 44 mm. Signed and dated 'JS /1790 /I'.*
*PD.1–1993. Not in BP. Bequeathed by Angus I. Macnaghton.*

In spite of his large following Smart did not receive much patronage from the Royal family, nor was he appointed to the Royal Academy. These may have been factors influencing his decision to work in India at a time when many other artists were attracted there by the prospects of rich rewards. He arrived in Madras in 1785, and stayed till 1795. Smart added the letter I to his initials when signing the miniatures he painted in India.

(A) The sitter in the upper miniature is wearing the uniform of an officer of the East India Company Forces. Major Sir Alexander Allan of Kingsgate was Deputy Quartermaster General to the Grand Army in the Mysore War of 1799. He resigned from the Madras Army in 1804. He was made a Baronet in 1819, the year before his death.

(B) The lower miniature is unusual in representing a Frenchman, identified as such by his wearing the cross of the Order of Saint-Louis. This portrait was also painted in India, in 1790.

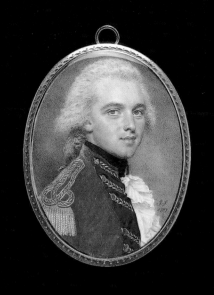

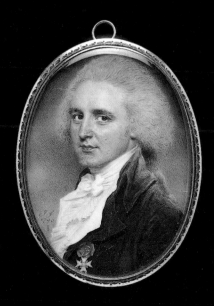

# JOHN SMART

&bull;

(A) AN INDIAN PRINCE · TOP

*Ivory. Oval. 2¹/₄ × 1⁵/₈ in. 57 × 42 mm. Signed and dated
in black 'JS /1788 / I'. PD.16–1948. BP, p. 201.*

(B) CHARLES, 1ST MARQUIS
CORNWALLIS (1738–1805) · BOTTOM

*Ivory. Oval. 2³/₈ × 1⁷/₈ in. 60 × 46 mm. Signed and dated
in black 'JS / 1792 / I'. No. 3922. BP, p. 202.*

(A) Smart spent almost all his ten years in India in Madras. He was miniature painter to Muhammad Ali, Nawab of Arcot, and four miniatures of him by Smart are known. The miniature of a young Indian Prince is believed to represent a member of his family, probably his grandson. When Smart left India in 1795 the Nawab owed him over 4,000 pagodas, and he claimed 6 per cent interest on this debt, which was still outstanding in 1804.

(B) Cornwallis took part in many of the important campaigns of the late eighteenth century: in America, Ireland and India. He was appointed Governor-General and Commander-in-Chief in India in 1786. There he set about eliminating corruption in the East India Company and restoring the morale of the Army. By defeating Tippoo Sultan at Seringapatam in 1792 (the year this miniature was painted) he ended the Mysore Wars and broke Tippoo's power.

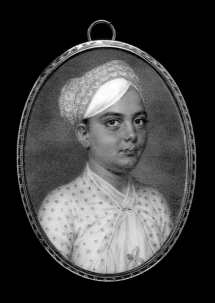

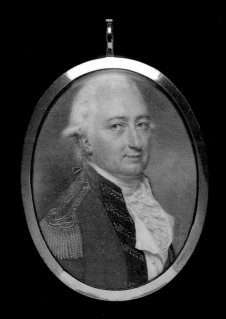

# OZIAS HUMPHRY, R.A. (1742–1810)

(A) LADY ELIZABETH BERKELEY (d.1828) · TOP
*Ivory. Oval. 1³/₄ × 1³/₈ in. 45 × 38 mm. Signed in black 'O H'.*
PD.62–1948. BP, p. 139.

–

# JOHN BOGLE (c. 1746–1803)

(B) AN UNKNOWN OFFICER · BOTTOM
*Ivory. Oval. 1³/₄ × 1³/₈ in. 44 × 34 mm. Signed and dated in black*
'I.B / 1793'. No. 3823. BP, pp. 8–9.

Ozias Humphry began his career in Bath, where he succeeded to the practice of his teacher Samuel Collins at the time Gainsborough was working there. Sir Joshua Reynolds encouraged Humphry to go to London, where he soon became fashionable. His style is notable for its robustness, and for a deep and harmonious colouring which is reminiscent of Reynolds's tonality. Humphry had ambitions as a painter in oils, but his career was cut short by failing eyesight and he abandoned miniature painting in 1792.

(A) The miniature by him at the top of this plate was painted when he was at the height of his powers, around 1770. It represents Elizabeth, second daughter of the 4th Earl of Berkeley. She had an adventurous career, separating from her first husband Lord Craven in 1780. Horace Walpole saw her that year in the audience watching a performance of her play 'The Miniature Picture' and was impressed by her 'integrity and frankness in her consciousness of her beauty and talents'.

(B) John Bogle is one of the ablest miniaturists who began their career in Scotland in the second half of the eighteenth century. His work is distinguished by its sharp lighting and pronounced use of minute stippling. He worked in London for nearly thirty years, returning to Edinburgh for the last four years of his life. The present miniature portrays an officer of the 1st Regiment of Foot Guards.

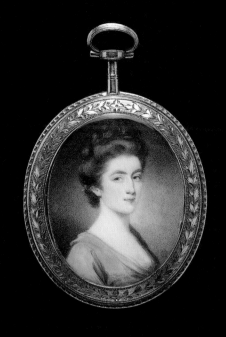

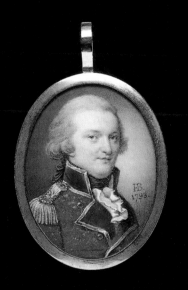

# RICHARD CROSSE

## (1742–1810)

(A) MRS JOHNSTONE · TOP

Ivory. Oval. 3¹/₈ × 2¹/₂ in. 79 × 62 mm. PD.982–1963. BP, pp. 54–5.

(B) THE REV. THOMAS GIBBONS (1720–1785) · BOTTOM

Vellum. Oval. 3¹/₄ × 2⁵/₈ in. 83 × 67 mm. Signed in black 'R.Crosse Fect'.
PD.25–1977. BP, p. 55.

Richard Crosse kept a sitters' book for the twenty-four years between 1775 and 1798 which gives a valuable insight into the amount of patronage available for miniaturists at this time. In the earlier years he often painted about a hundred miniatures a year. He had the misfortune to be born a deaf-mute, and throughout his life he entertained a hopeless passion for the lady who became the mother of Benjamin Robert Haydon. In his *Autobiography* Haydon gives an affecting account of a chance meeting between his dying mother and her embittered lover.

(A) Crosse records painting the top miniature in his fee book for 1779; it is on a scale larger than the usual size of his works.

(B) The lower miniature represents the dissenting minister Thomas Gibbons, who taught metaphysics at the Mile End Academy. Dr Johnson enjoyed his company. The miniature is unusual in Crosse's work in being painted on vellum, by then now almost entirely out of use, and in being signed on the front. It is recorded in his fee book for 1783.

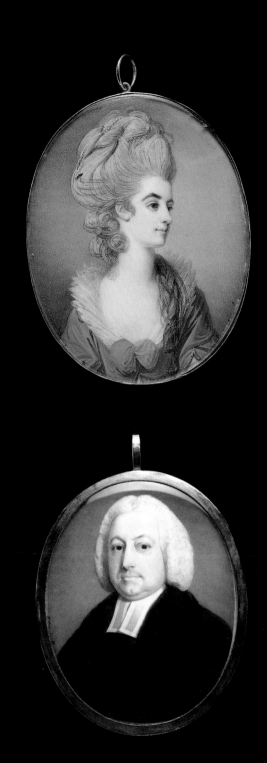

# GEORGE ENGLEHEART (?1753–1829)

~

WILLIAM HAYLEY (1745–1820)
Ivory. Oval. 3$^1/_2$ × 2$^3/_4$ in. 89 × 71 mm. PD.10–1965. BP, p. 77.

The keen demand for miniature portraits at the end of the eighteenth century and beyond, noticed in the case of Richard Crosse (see no. 50), is even more forcibly illustrated by the long and active career of George Engleheart. The fee books he kept from 1775 until 1813 provide a remarkable record of patronage and artistic industry. They record 4,853 miniatures painted by him in thirty-nine years, an average of 124 portraits a year.

This miniature of William Hayley descends from his second wife Mary Welford, whom he married in 1809. Engleheart's fee book records portraits of Hayley in 1809 and 1810; this is probably the former, painted as a marriage portrait.

Hayley aspired to fame as a poet and playwright, but is better known for his friendships with poets and painters. He befriended Meyer (see nos. 39–41) and Romney, and wrote a life of Cowper. He encouraged Blake (see no. 60) to stay at a cottage he owned at Felpham. Though the intention was kindly Blake came to feel that his independence was being threatened and the visit ended in disharmony.

The Fitzwilliam Museum possesses a large collection of letters by William and Elizabeth Hayley, amongst which is one dated 3 November 1816 to Meyer's daughter Mary (see no. 41).

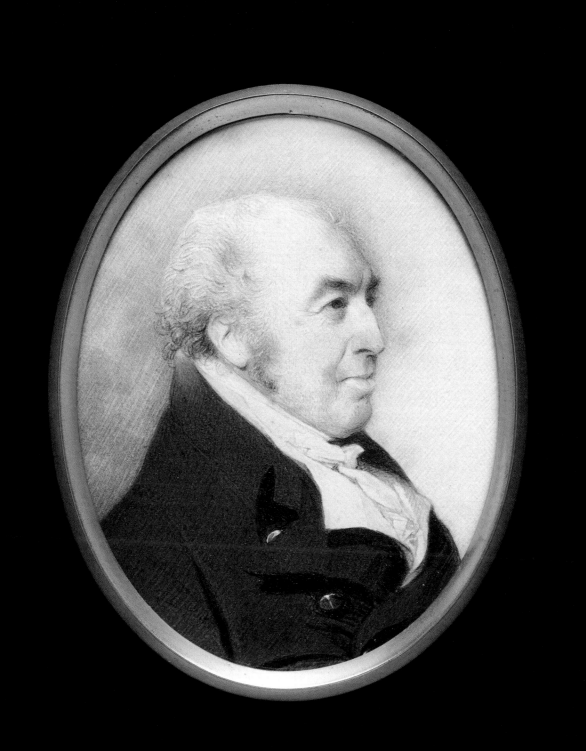

# GEORGE ENGLEHEART

—

(A) HENRY C. DRUMMOND · TOP

*Ivory. Oval. 1⁷/₈ × 1⁵/₈ in. 49 × 40 mm. At the back are
the initials in gold 'H.C.D'. No. 3758. BP, p. 73.*

(B) MRS LINDSAY? · BOTTOM

*Ivory. Oval. 2³/₈ × 2 in. 61 × 51 mm. Signed in grey 'E'.
The miniature is in a gold frame set with pearls and bows of blue enamel.
The back has the initials 'H S L' in small white beads on hair.
No. 3914. BP, p. 75.*

Nothing is known about these two sitters. The portrait of Mr Drummond may
be recorded in Engleheart's fee-book for 1789, and that of Mrs (or Miss)
Lindsay in that for 1790. Both are characteristic examples of Engleheart's
direct observation and solid portraiture c. 1790. It may be noted that in 1788
he painted 228 miniatures, a tally which explains a certain repetitiveness in
his output.

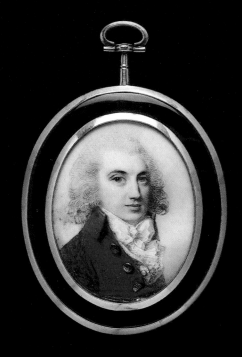

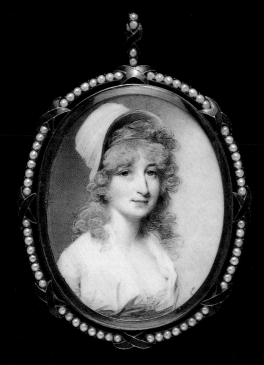

# GEORGE ENGLEHEART

—

(A) MASTER BUNBURY · TOP
Ivory. Oval. $2^1/_2 \times 2$ in. $65 \times 50$ mm. No. 3838. BP, p.76.

(B) AN UNKNOWN MAN, 1804 · BOTTOM
Ivory. Oval. $3^5/_8 \times 2^{15}/_{16}$ in. $92 \times 75$ mm.
Signed in black 'E'; the card at the back is signed and dated by the artist
'G Engleheart / pinxit / 1804'. PD.8–1977. BP, p. 76.

(A) The miniature at the top is not recorded in Engleheart's fee book showing that, comprehensive as it is, it does not record absolutely all his vast output. The identity of the sitter and its traditional date of 1802 is confirmed by comparison with a splendid miniature of the same boy by Cosway. It has not been possible to establish a relationship with the Bunbury family of Barton Hall.

(B) Engleheart responded to the onset of the nineteenth century by emphasising the more solid and even sombre aspects of his sitters' characters. This aspect of his art is seen in the unidentified male portrait of 1804.

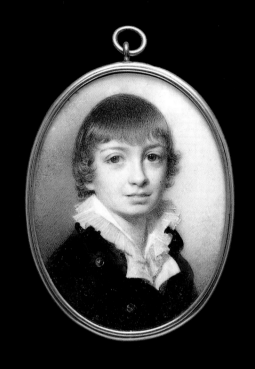

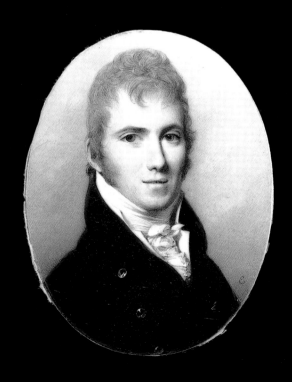

# SAMUEL SHELLEY (c. 1750–1808)

### (A) AN UNKNOWN LADY · TOP

*Ivory. Oval. 2¹/₈ × 1¹/₂ in. 54 × 40 mm. Signed on the back 'S Shelley / Henrietta Street / Covent Garden'. PD.217–1961. BP, p. 197.*

—

# HORACE HONE A.R.A. (1754–1825)

### (B) MRS ANNE CATHERINE FITZGERALD · BOTTOM

*Ivory. Oval. 3 × 2¹/₂ in. 78 × 64 mm. Signed and dated in black 'H H / 1787'. A label on the back is inscribed 'April 1837 / Mrs Fitzgerald / her picture to /be given to her / G Gd daughter / Anne Fitzgerald /' and two other labels on the back give biographical details and a note of the miniature's descent to the sitter's great-great-grandson, L.A.G. Strickland of Cambridge. PD.210–1961. BP, p. 124.*

(A) Samuel Shelley, the painter of the top miniature, had a high reputation in his own day. When the American miniaturist Edward Malbone came to England in 1801 in search of instruction he considered that he had most to learn from Cosway and Shelley, and copied a composition by the latter. Shelley aspired to paint historical and literary subjects in watercolour, on paper as well as on ivory, and was a founder of the 'Old' Watercolour Society in 1804 to further that ambition. His miniatures are characterised by the use of a yellowish-green flesh tint, and have much charm.

(B) Horace Hone was the son of Nathaniel Hone (see no. 37). He spent the most fruitful years of his career in Dublin, where he worked from 1782 until 1804. Then, finding his practice diminished by the Act of Union, he returned to England. The lower of these two miniatures was painted by him in Ireland. It represents Anne Catherine Burton, the wife of Edward Fitzgerald of Carrygoran. He was M.P. for County Clare and rebuilt the family's house Carrygoran.

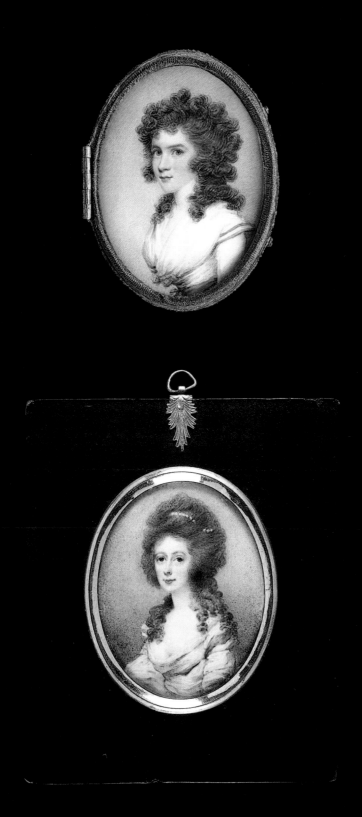

# ANDREW PLIMER (1763–1837)

◦

### (A) AN OFFICER · TOP
Ivory. Oval. 2 × 1⁵/₈ in. 52 × 41 mm. PD.215–1961. BP, p. 180.

### (B) JOHN C. WILLES · BOTTOM
Ivory. Oval. 3 × 2³/₈ in. 76 × 62 mm. *The back of the frame has the initials*
*'JCW' in gold surrounded by plaited hair set in blue glass over foil. A label on the*
*back identifies the sitter as John Willes of Hungerford Park, Berkshire.*
No. 3799. BP, p. 182.

Andrew Plimer is said to have spent two years with a band of gipsies and then become a servant to Richard Cosway, in which capacity he learned to paint miniatures. He was popular in his own times, but then was almost forgotten. He was rediscovered in the late nineteenth century and, aided by some wild attributions to him of works by other artists, a place was claimed for him beside the leading masters of the late eighteenth century. His work was too stereotyped to sustain this distinction, but he painted many pleasing portraits which reflect the way his sitters wished to be portrayed.

(A) The young officer is wearing the uniform of a Battalion Company Officer of an unidentified regiment.

(B) Nothing is known about Mr Willes apart from this miniature and its label. He was presumably painted c. 1795. In this portrait the mannerisms of Plimer's handling are conspicuous in the long hooked nose and the cross-hatching above the head and in the background.

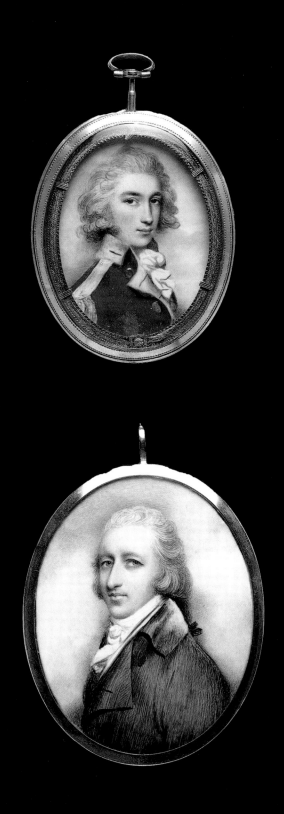

# PHILIP JEAN (1755–1802)

(A) MARGARET ROGERS,
LATER MRS TYERS (1722–1806) · TOP

Ivory. Oval. 2³/₄ × 2¹/₄ in. 68 × 58 mm. Signed and dated in grey
'P J /1787'. The back is inscribed in ink 'Margt. Rogers / widow of R;d
Dawson / 2 Jona. Tyers'. PD.212–1961. BP, p. 145.

#### ●

# JOHN BARRY (WORKED 1784–1827)

#### ●

(B) WILLIAM LINLEY (1771–1835) · BOTTOM

Ivory. Oval. 2¹/₈ × 1¹/₂ in. 53 × 38 mm. No. 3821. BP, p. 4.

(A) Philip Jean served in the Navy before taking up miniature painting; as a result there are many naval officers amongst his sitters. The top miniature represents Margaret Rogers who first married Richard Dawson and secondly Jonathan Tyers junior (d. 1792). Her second husband was the younger son of Jonathan Tyers, founder of the famous pleasure grounds at Vauxhall Gardens; he took part in its management from 1767 until his death. Jean painted eleven miniatures of the Tyers family. There is a slightly smaller version of this portrait in the Institut Néerlandais, Paris.

(B) John Barry's miniatures are usually unsigned, but can be recognised by the sharply angled strokes with which he paints the eyebrows. The lower miniature represents William Linley, the youngest son of the composer, Thomas Linley the Elder (1733–95). The Linleys were a famous musical family in Bath and became close friends of Thomas Gainsborough, who painted portraits of many of them. William Linley worked for some years for the East India Company. On his return to England in 1806 he devoted himself to literature and musical composition. He bequeathed seven portraits of the Linley family, four by Gainsborough and three by Lawrence, to the Dulwich Picture Gallery.

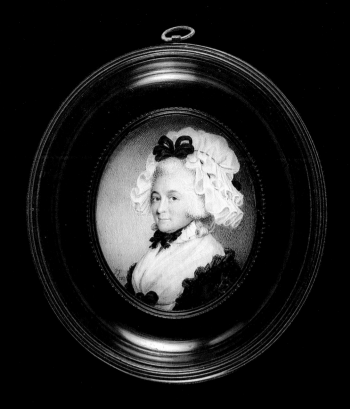

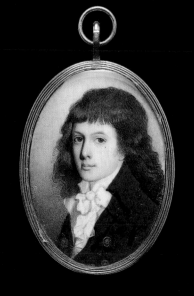

# HENRY EDRIDGE, A.R.A. (176?/8/9–1821)

(A) SAMUEL HALLIFAX,
BISHOP OF GLOUCESTER (1733–1790) · TOP
Ivory. Oval. 2¹/₂ × 2 in. 63 × 52 mm. PD.15–1952. BP, p. 69.

–

# SIMON JACQUES ROCHARD (1788–1872)

(B) GEORGIANA CAROLINA,
LADY ASTLEY (1796–1835) · BOTTOM
Ivory. Oval. 2³/₄ × 2 in. 69 × 51 mm. Signed in white 'Rochard'.
Set in the lid of a gold box. No. 3719. BP, p. 189.

Henry Edridge began to exhibit miniatures at the Royal Academy at the age of eighteen in 1786 and attracted a member of clients for his robust portraiture in this medium. But after some fifteen years his eyesight began to weaken, and he transferred his interest to full-length portraits in pencil and watercolour, and to watercolour landscapes.

(A) Hallifax was the private tutor of Richard, 7th Viscount Fitzwilliam, the founder of the Fitzwilliam Museum, when he was an undergraduate at Trinity Hall, 1761–64. He became Professor of Arabic, and then of Civil Law in the University of Cambridge. This miniature was painted when he was Bishop of Gloucester. It is one of Edridge's earliest works, having been exhibited at the Royal Academy in 1788 and engraved by Godby in the same year.

The course of miniature painting in France in the late eighteenth and early nineteenth centuries was markedly different from that pursued in England. It reflected in turn the decorative nature of the Rococo, the severe Republicanism of David and the Romanticism of Delacroix. Simon Jacques Rochard came to England in 1816 after training in the traditions of Augustin and Isabey, and the variety he brought to the national school earned him rich rewards.

(B) The lower miniature is a smaller version in reverse of a rectangular miniature by Rochard in the Victoria and Albert Museum which is dated 1827. Georgiana Carolina Dashwood married in 1819 Sir Jacob Astley, 6th Bart, who became the 16th Baron Hastings.

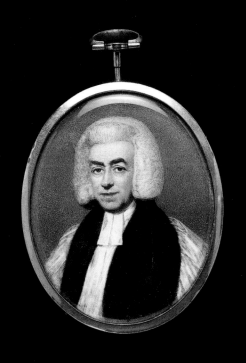

# WILLIAM WOOD (1769–1810)

CARL FRIEDRICH ABEL (1723–1787), AFTER GAINSBOROUGH

*Vellum. Rectangular. 5⁷/₈ × 4 in. 148 × 102 mm. Bequeathed by Daniel Mesman.*
*Inscribed by the artist in pencil 'ISSNG. Abel. W Wood.'*
No. 4108. Not in BP.

More is known about William Wood than about most miniaturists of his time. Not only did he keep a fee book, as had Richard Crosse and George Engleheart: he made detailed records in his ledgers of the size of his ivories, their preparation and the pigments used in his portraits. These notes are frequently accompanied by a tracing of the completed miniature. The ledgers, now in the Victoria and Albert Museum, provide the identity of many of his sitters and give a detailed account of a late eighteenth-century miniaturist's method of working. They show that in the nineteen years between 1790 and 1808 he painted 1,211 miniatures, an average of over sixty a year. The present miniature is described in the artist's ledger of drawings, as '10,039. A head of the late / Mr Abel (musician). /After an unfinished Portrait / by Gainsborough, in the /possession of Col./ Kirkpatrick / Began 1 Oct. 1801 / Fin'd 27 Novr.' This is followed by a list of the pigments used, in Wood's unsolved numerical code. He concludes 'A man's head; abt two inches in its oval / Treated as a minre[miniature] /Fair in the complexion.' The letters 'ISSNG' in the artist's inscription no doubt stands for the number 10,039 for its entry in his ledger.

Carl Friedrich Abel (1723–87), composer and player on the viol-de-gamba, was a friend of Gainsborough and collected many of his drawings, acquired in exchange for his music. Gainsborough's main portrait of him is in the Huntington Art Gallery. The unfinished version from which this was copied was bought from Mrs Gainsborough's sale in 1797: Christie's copy of the sale catalogue gives the purchaser's name as Kilpatrick. It was with the McBride galleries, New Orleans in 1983.

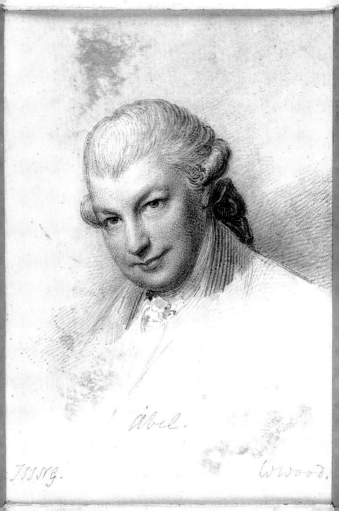

Abel.

J.S.W.G.                                        W.Wood.

59

# JOHN HAZLITT
## (1767–1837)

—

AN UNKNOWN LADY

*Ivory. Oval. 3⅝ × 3 in. 93 × 77 mm.*

PD.9–1970. BP, p. 107.

John Hazlitt was the elder brother of the essayist William Hazlitt, who was eleven years younger. He was taken to America by his father in 1783, and attempted in 1785 to open an art school in Boston with Joseph Dunkerley. He returned to England with his father in 1787. Much of his practice consisted in copying works by Reynolds and other artists.

Although he exhibited annually at the Royal Academy between 1788 and 1819 his miniatures are not frequently recognised. He painted four miniatures of his brother William between 1783 and 1813.

The present portrait was probably painted *ad vivum* shortly after his return from America. It shows his individual gift for the control of lighting and his honesty in the portrayal of his sitters.

124

# JOHN LINNELL
## (1792–1882)

●

WILLIAM BLAKE (1757–1827)

*Ivory. Rectangular.* 5¹/₄ × 4¹/₈ in. 133 × 106 mm. PD. 61–1950. BP, p. 153.

John Linnell first met William Blake in 1818. By commissioning the *Illustrations of the Book of Job* and the designs for Dante's *Divine Comedy* and by introducing him to new patrons he helped to save Blake from indigence in his last years. Linnell made many pencil drawings of Blake. The Fitzwilliam Museum has a study of Blake in conversation with John Varley and another of him at Hampstead. In 1861, forty years later, Linnell made a more finished copy of this miniature which is now in the National Portrait Gallery.

This miniature, like the pencil drawings, reveals Linnell's sympathetic insight into Blake's personality. Linnell undertook commissioned miniature portraits reluctantly, but when he did so imparted to them through his rough texture and bold stippling an idiosyncratic quality which marks them out from the work of his contemporaries. He remarked 'portraits I painted to live, but I lived to paint poetical landscape'. After 1846 it was no longer necessary for him to undertake portraits and he recommended anyone who approached him to sit to George Richmond (see no. 62).

The Museum's collection of works by Blake and of related material was greatly enhanced in 1985 through a large bequest from Sir Geoffrey Keynes. The books in that bequest are in the University Library, Cambridge.

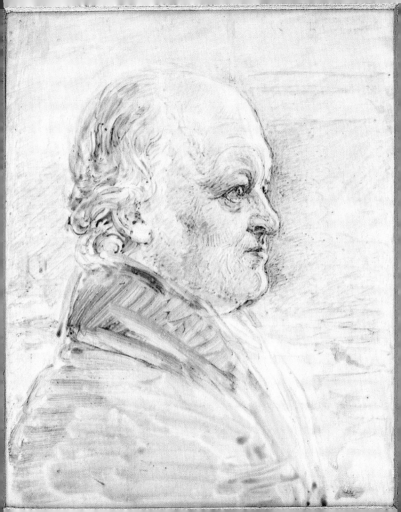

# JOSEPH SEVERN
## (1793–1879)

●

JOHN KEATS (1795–1821)
*Ivory. Rectangular.* $4^1/_4 \times 3^1/_4$ *in.* $108 \times 83$ *mm.*
*The miniature is framed with a lock of Keats's hair.*
No. 713. BP, pp. 195–6.

Joseph Severn was a struggling art student when he formed a friendship with John Keats around 1816. He resolved to accompany Keats to Rome in September 1820, and looked after him with devoted care. The poet died in his arms on 23 February 1821.

This miniature was painted as a token of the poet's love to be given to Fanny Brawne and was exhibited at the Royal Academy in 1819. Fanny Brawne sold the miniature to Keats's friend Charles Wentworth Dilke, whose grandson Sir Charles Dilke bequeathed it to the Museum. Severn painted a copy of this miniature in oil on ivory (the present version is in watercolour) which is now in the National Portrait Gallery. He made a number of copies and later versions and it has formed the basis of many posthumous representations of the poet.

Although he was awarded the Royal Academy's gold medal in 1818 for an historical painting Severn's artistic career did not fulfil early expectations. He had a considerable vogue as a portrait painter during his years as consul in Rome. His imaginative work consists in such fairy pieces as 'Ariel' and 'Nymph gathering honeysuckle' in the Victoria and Albert Museum. The Fitzwilliam has the manuscript of Keats's 'Ode to a Nightingale'.

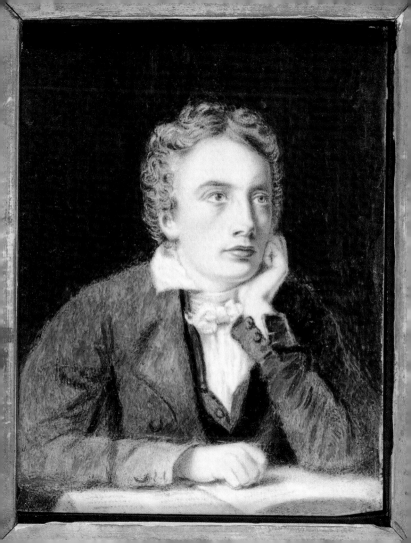

# GEORGE RICHMOND, R. A. (1809–1896)

AN UNKNOWN MAN

*Ivory. Rectangular. 4 × 3 in. 102 × 76 mm. Signed 'GR' (monogram) and dated 1830.*
*PD.221–1994. Not in BP. Given by the Friends of the Fitzwilliam with a*
*contribution from the Bayne-Powell bequest.*

George Richmond was the younger son of the miniaturist Thomas Richmond, who was a cousin of George Engleheart (see nos. 51–3). In his youth he was a member of the group of admirers of William Blake which called itself 'The Ancients' and which included Samuel Palmer, Edward Calvert and Frederick Tatham. Richmond's early work reflected the visionary aspirations of his fellow disciples. An afterglow of this influence is apparent in the landscape background and truthful vision of this miniature. It was painted in 1830, the year in which he eloped with the sister of Frederick Tatham and married her at Gretna Green.

After accompanying Samuel Palmer and his wife for a long visit to Italy between 1837 and 1839 he devoted himself to portraiture on his return, and became extremely successful in a more conventional mode. He specialised in portrait drawings and many celebrities sat to him. His portait drawing of Charlotte Brontë is the image by which she is most recognised. His ideal for portraiture was that it should represent 'the truth lovingly told'.

The only male sitter for a miniature recorded in George Richmond's sitter's book for 1830 is Mr Ashby and this may be his portrait.

# SIR WILLIAM CHARLES ROSS, R.A.
## (1794–1860)

—

AN UNKNOWN LADY

*Ivory. Rectangular. 5¹/₄ × 4 in., on surface 5⁷/₈ × 4³/₈ in. 133 × 100 mm.,*
*on surface 148 × 112 mm. Signed on the verso: 'Painted by Sir W. C. Ross R.A.*
*Miniature Painter to the Queen. 1852.' PD.218–1994. Not in BP.*
*Bequeathed by Robert Bayne-Powell.*

At the beginning of the nineteenth century a new generation of miniaturists set about reforming the methods of miniature painting. This movement was led by Andrew Robertson, who despised the sketchy qualities he found in Cosway and his contemporaries, and sought to rival the depth and finish of oil painting when using watercolour on ivory. Ross became Robertson's assistant in 1814, and devoted himself to painting miniatures in the new manner. The last great national exponent of the art, he had a marked talent for showing his sitters in their most genial and sympathetic moods. His leading position was confirmed when Queen Victoria appointed him as her miniature painter in 1837.

Ross lived into the era in which the advent of photography threatened the survival of miniature painting. But many patrons, above all the Queen, remained faithful to this most intimate form of portraiture, and he painted over 2,200 miniatures in the course of his career.

# CHARLES RICKETTS
## (1866–1932)

—

MISS EDITH EMMA COOPER (1862–1913)
*Card. Circular. 1³/₈ in. 34 mm. diameter. Inscribed with the monogram 'MF'
and with twinned rings. Set in 'The Pegasus Locket', made of gold with white and green
enamel and set with pearls, garnets and rubies. Size of locket 4 × 2 in. 100 × 50 mm.*
M.3–1914. BP, pp. 187–8.

Edith Cooper was the niece and lifelong friend of Katherine Bradley. They collaborated in twenty-seven poetic dramas and eight volumes of lyric poetry, published under the name 'Michael Field'. Charles Ricketts became a close friend of the couple and decorated a number of their volumes for the Vale Press. To him, as to all their inner circle, Edith was known as 'Henry' and Katharine as 'Michael'.

Ricketts was passionately fond of precious stones and when in the 1890s he began to design jewelled settings for gems, Michael and Henry were amongst his most enthusiastic patrons. The present locket was made by Giuliano Freres to Ricketts's design for Michael, to enclose the miniature portrait of Henry. For the pendant enclosing the portrait Ricketts adapted the motif of Pegasus drinking at the Fountain of the Hippocrene from a gem in the Marlborough Collection. In the portrait Ricketts adopted the pose in profile from the cameos for which he had designed frames. Its completion in October 1901 was celebrated by a dinner at which Michael, Henry, Charles Ricketts and Charles Shannon wore the locket in turn 'looking like ecclesiastics wearing some starry symbolic gem'. It was bequeathed to the Museum by Katharine Bradley.

The form of the earliest portrait miniatures was derived from the profile or three-quarter-face portraits in cameos, coins and medals. In this late and rare example of the genre, Ricketts has returned to those sources for his model.

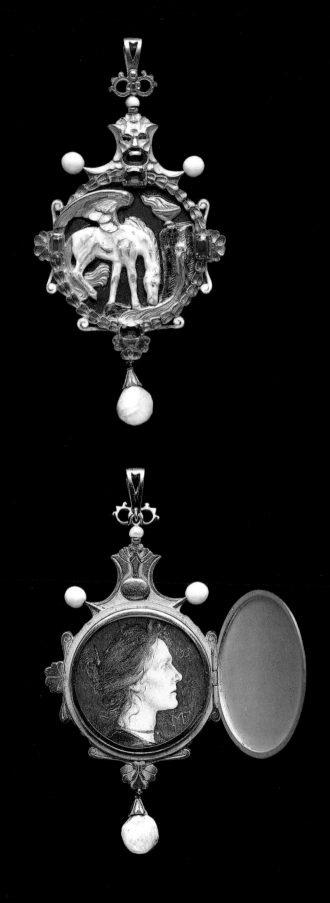